A SECRET SERVICE

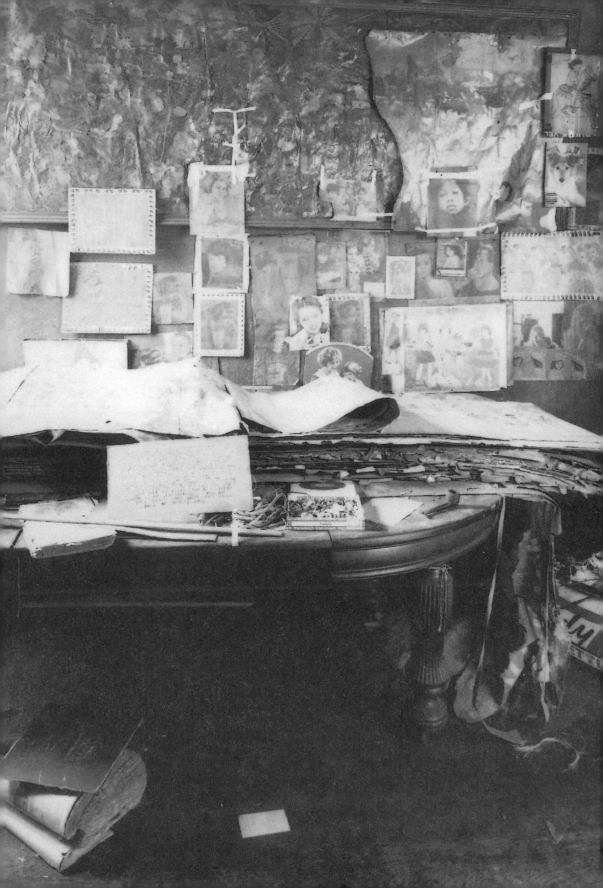

Richard Cameron
Clare Carolin
Roger Cardinal

A SECRET SERVICE

ART, COMPULSION, CONCEALMENT

HAYWARD GALLERY TOURING
South Bank Centre, London

Published on the occasion of *A Secret Service: Art, Compulsion, Concealment*, a Hayward Gallery Touring Exhibition in collaboration with the Hatton Gallery, University of Newcastle

Exhibition tour:

17 September – 11 November 2006
Hatton Gallery, Newcastle

27 January – 15 April 2007
De La Warr Pavilion, Bexhill on Sea

5 May – 29 July 2007
Whitworth Art Gallery, Manchester

The Hayward Gallery and the Hatton Gallery would like to thank The Henry Moore Foundation and the Esmée Fairbairn Foundation for their generous contribution to the catalogue.

 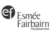

Exhibition curated by Richard Grayson
Exhibition organised by Clare Carolin assisted by Rachel Kent and Sherman Sam

Art Publisher: Charlotte Troy
Publishing Co-ordinator: Shela Sheikh
Sales Manager: Deborah Power
Catalogue designed by Fraser Muggeridge studio
Printed by Graphicom in Italy

Cover, cat. 22 Tehching Hsieh, *One Year Performance (1980–81)*, 1981
Inside cover Kurt Schwitters, *Merzbau (detail: stairway entrance)*, c.1932 (detail)
pp. 2–3, fig. 1 West wall of Henry Darger's room, 1978
p. 49, cat. 7 Henry Darger, *Blandanion Blengin or Tuskorhorian*, date unknown
p. 118, cat. 43 Jeffrey Vallance, *My FBI File*, 1981

Published by Hayward Gallery Publishing, South Bank Centre, London SE1 8XX, UK, www.hayward.org.uk

ISBN 1-85332-256-3 / 978-1-85332-256-3

Hayward Gallery Publishing titles are distributed outside North and South America by Cornerhouse Publications, 70 Oxford Street, Manchester M1 5NH (tel. +44 (0)161 200 1503; fax. +44 (0)161 200 1504; email: publications@cornerhouse.org; www.cornerhouse.org/books).

FOREWORD

Exhibitions made in collaboration with partner organisations are an important element of the Hayward Gallery Touring exhibition programme and result in some of our most dynamic projects. The Hayward's involvement with *A Secret Service* began in 2004 when Lucy Jenkins, Curator at the Hatton Gallery, Newcastle University proposed to Roger Malbert, the Hayward Senior Curator, an exhibition based around the notion of secrets and concealment in modern and contemporary art. It was a project developed by artist and curator Richard Grayson, then an Arts and Humanities Research Board Fellow at the Newcastle University. As Richard describes in his essay included in this book, the awkward and enigmatic qualities of Kurt Schwitters' *Merzbarn* provided the point of departure for his thinking about the relation between secrecy and art making. The *Merzbarn* has been permanently installed at the Hatton Gallery since the mid-1960s when, at the instigation of Richard Hamilton, it was moved from Cylinders, the farm in the Lake District where Schwitters created it. Without its presence there as a source of inspiration to this exhibition, and the collaboration of the Hatton Gallery who nurtured the project in its early stages and have worked closely with us towards its realisation, *A Secret Service* might never have come to fruition.

Secrecy is an unusual, even paradoxical, subject for a public exhibition, yet the international range of work in all media – from drawing and sculpture to video and performance – testifies to the importance of concealment in the creative act, and its prevalence in the wider frame of society and politics. Metaphorically, secrecy is strongly associated with vision: we speak of keeping information from view, being in the dark, and the opacity or invisibility of that which is beyond our comprehension. The work of many modern artists, in particular Schwitters, plays knowingly with the multivalent qualities and implications of secrecy – concealing, revealing and spinning elaborate and impenetrable codes around itself. The fact that much of the more recent work in *A Secret Service* – such as that of Mark Lombardi, The Speculative Archive and Jeffrey Vallance – sets out to expose facts and images that have been withdrawn from public access demonstrates that together with the current cultural tendency towards the free-flow of information goes an unremitting impulse to withdraw things from view.

My first thanks go to Richard Grayson for the inspired and original thinking that has driven this project, and for his rigorous and fascinating essay. It has been a pleasure to collaborate with the Hatton Gallery and we offer our particular thanks to the Hatton's Curator, Lucy Jenkins, and Exhibition Officer, Liz Ritson. The Hatton's Education Officer, Jean Taylor, has worked closely with the Hayward Gallery's Public Programmes Assistant, Sophie Higgs, to create complimentary resources for the exhibition, and for this we thank them both.

We are delighted that the exhibition will tour to the De La Warr Pavilion, Bexhill on Sea and the Whitworth Gallery, University of Manchester and extend our thanks to the staff of these venues for embracing the project with such enthusiasm: Celia Davies, Curator at the De La Warr Pavilion, and Curators at the Whitworth, David Morris and Mary Griffiths. Thanks are also due to

David Lomas and the Centre for Surrealism Studies at the University of Manchester for their support of the project.

Roger Cardinal, together with Victor Musgrave, co-curated the Hayward Gallery's 1979 exhibition *Outsiders* that included work by Henry Darger and Oskar Voll who both appear in *A Secret Service*. We thank Roger for his enthusiastic support of this project and for the absorbing essay that appears here. Monica Kinley and Jon Thompson have both collaborated with us in the past; we appreciate their advice and stimulating input into this project.

Hayward Exhibitions Curator, Clare Carolin, Assistant Exhibition Organiser, Rachel Kent, and Inspire Fellow, Sherman Sam, have been responsible for realising the exhibition and I am grateful to them for their attention to its organisational needs as well as for the texts which appear in this book. I am also grateful to the Hayward's Art Publishers, Caroline Wetherilt and Charlotte Troy and to Publishing Co-ordinator Shela Sheikh for their expertise and attention to this book. It has been designed by Fraser Muggeridge and his sensitivity and responsiveness to the aesthetic and logistical demands of the project are greatly appreciated. Adrian Dannatt and Joachim Koester worked with us to produce the 'Pan Museum Newspaper' that is bound inside this book and I extend my thanks to them as well as its designers Daniel Van der Velden and Maureen Mooren. I also thank the Henry Moore Foundation and the Esmée Fairbairn Foundation for their very generous support of this catalogue.

We are indebted to every lender to the exhibition but must make special mention of the following individuals: Kyoko Lerner for her early commitment to the project and consistent help and generosity; Jacques Mercier for deciphering the magic of Gedewon's talismanic art and sharing it with us; Lois Keidan and Daniel Brine at Live Art Development Agency and Adrian Heathfield without whom it would have taken far longer for us to locate Tehching Hsieh; Joanna Diem at the Foksal Gallery Foundation for her advice on the considerable logistical demands of Katarzyna Józefowicz's work; Ted Bonin at Alexander Bonin, Jan Endlich at Lehmann Maupin and Summer Guthery at Pierogi 2000 for navigating us through the complexities of the work of Paul Étienne Lincoln, Jeffrey Vallance and Mark Lombardi respectively; the staff at Timothy Taylor Gallery for their assistance with the work of Susan Hiller; Caroline Collier and Catherine Clement at Tate for their help in facilitating the loan of work by Sophie Calle; Dr Thomas Roeske at the Prinzhorn Museum for accommodating our request for the loan of work by Oskar Voll and Karin Orchard at the Sprengel Museum for her patient responses to endless questions.

This exhibition would of course not have been possible without the support and engagement of the artists. They have readily participated in dialogue, responded generously to our requests and influenced the shape, look and feel of the exhibition and catalogue. Our greatest debt of gratitude goes to them.

Ralph Rugoff
Director, Hayward Gallery

Not so long ago, the Hatton Gallery was regarded as something of a secret. Located at the heart of Newcastle University's campus, the route from the city centre takes the visitor through an arched gateway into a beautiful, enclosed quadrangle. The setting creates a real sense of discovery, the feeling that you have found a 'hidden gem'. Widening audiences is a challenge that faces most smaller, regional galleries and it is sometimes seen as incompatible with maintaining a sense of mystique or with presenting more challenging exhibitions. *A Secret Service* dispels that myth. The work in the exhibition is complex, multifaceted and intriguing whilst its concerns mirror those of wider society.

It has been tremendously exciting for the Hatton Gallery to commission Mike Nelson to create a new work and we would like to thank him for making such a fascinating contribution to the exhibition.

Funding from Arts Council North East has made it possible for the Hatton Gallery to collaborate with Hayward Gallery Touring on an exhibition of this scale and we therefore gratefully acknowledge their support. The Arts and Humanities Research Council supported the Fellowship of Richard Grayson at Newcastle University and it was from this research project that *A Secret Service* emerged. Newcastle University has also provided financial assistance for early research. It has been a pleasure to work alongside Richard Grayson and Hayward Gallery Touring, and I would like to extend my very warm thanks to all those involved in *A Secret Service*.

Lucy Jenkins
Curator, Hatton Gallery

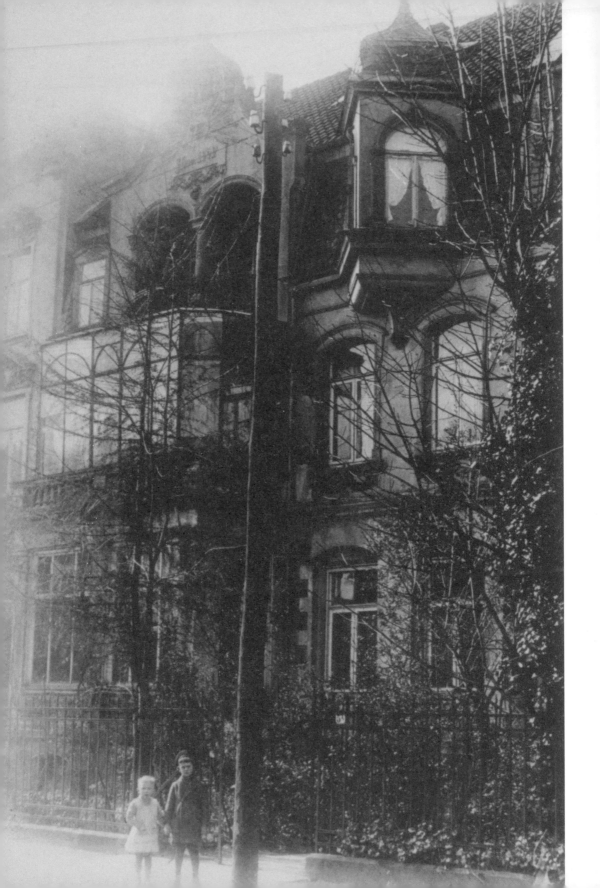

IN A SECRET SERVICE

> Any window that might have afforded a glimpse of the
> *Merzbau* from outside was now whitewashed over …
>
> Gwendolyn Webster, *Kurt Merz Schwitters*, University of Cardiff Press, Cardiff, 1997, p. 270.

The Hanover *Merzbau* that Kurt Schwitters considered his life's work probably started as a bricollaged tower in a corner of the artist's studio. To this he added niches, caves and rooms so that by degrees the work became a complex, architectural environment. Over a period of at least 20 years, until Schwitters' departure from Hanover to Norway in 1937, the *Merzbau* accreted, layered, shifted, expanded and transformed. Images and objects – often personal, sometimes stolen – were placed, ordered, linked and buried within it: Sophie Tauber-Arp's stolen bra, pencils taken from the desk of Mies van der Rohe and numerous items belonging to Schwitters' friend Kate Steinitz including, 'a lost key of mine that I had been searching for desperately'.[1] The building of the *Merzbau*, with its sealing off of spaces and objects, meant that over the lengthy process of its construction it eventually comprised a closed archive of its own history. The smooth white volumes and forms that we can see in the photographs that Schwitters published in the avant-garde journal *Abstraction Création* in 1933 conceal a great deal of the work's development and history.

Schwitters
pp. 25–28
cats 2–4

As if to amplify the secretive logic of its construction, Schwitters allowed only a few people to see the *Merzbau*.[2] This hesitation to allow it into public view becomes stranger when one considers his talent for publicity and highly modern understanding of it as a condition of success. Schwitters deployed everything from poster blitzes and guerrilla advertising, to newspaper articles and adverts, in order to generate profile and attention for his work and career. For instance, his poem *An Anna Blume* started as an avant-garde *succès-d'estime* but ended up as 'possibly the best known and most popular German verse of the 1920s',[3] because 'brash publicity finally catapulted the poem and its author to national fame…'.[4] The Dada artist Hans Richter said that in the person of Schwitters he had 'never seen such a combination of complete lack of inhibition and business sense, of pure and unbridled imagination and advertising talent.'[5] Despite Schwitters' often commented upon eccentricities – his baggy suits, stiff collars and socklessness – he can be seen not only as a romantic eccentric, but also as an artist who knowingly articulated his activities through branding and a shrewd hard-headed approach to 'getting on'.

Schwitters
pp. 97–101
cats 30–34

The Hanover *Merzbau* was completely destroyed by Allied bombs in 1943 but our fragmentary knowledge of it, and its subsequent incarnations in Norway and Elterwater in the Lake District – also destroyed or fragmentary – is a result not only of the erasures of war and the deaths of the few who saw it, but also of the intrinsic nature of the work in each of its forms, and the active choice of the artist. The *Merzbauten* (or *Merzbuildings*) were largely, but not exclusively, private undertakings that took place in 'non-public' spaces: closed worlds. Furthermore, they articulated the world and Schwitters' relation to it in ways that denied easy access, sometimes expressing intimate almost pathological concerns, at others rearticulating the artist's experience in more

fig. 2 Ernst Schwitters (in cap) and unknown child in front of 5 Waldhausenstrasse, April 1926

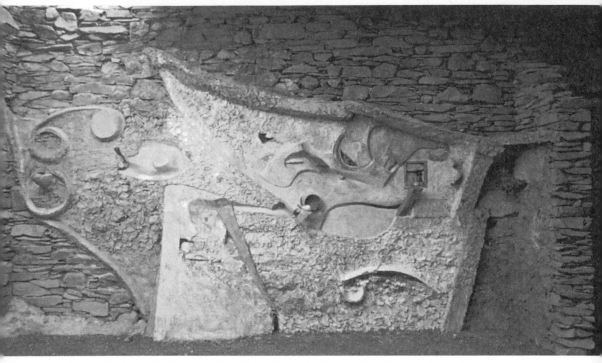

fig. 3 Kurt Schwitters, *Merzbarn wall*, 1947–48, (installed at the Hatton Gallery, Newcastle University)

formal hermetic ways, and making these shifts and changes over a time-span that meant that they were very difficult to get to know in any commonly understood way. Schwitters suspected that only three people other than himself intimately knew the Hanover *Merzbau*.

A part of a wall from the last *Merzbau* – the *Merzbarn*, which Schwitters see above fig. 3 began building in 1947 on a farm in the Lake District, following his move from Norway to the UK – is now in the Hatton Gallery in Newcastle University. It was during a fellowship there that I slowly came to realise quite how peculiar, secretive and awkward the *Merzbau* was, how it refuses easy understanding, and how vast areas of its intentions and histories remain withdrawn from us. This became the matter of *Ghost Houses*, a performance and video work that I made in 2003–04, which explored lost architectures and ways that the *Merzbau* might be imagined and understood. Of particular interest in the shaping of this work and the exhibition that has become *A Secret Service* was a talk by Roger Cardinal at Elterwater in the Lake District, the village close to the place where Schwitters made his final attempt at rebuilding the *Merzbau*. Cardinal showed slides of the Hanover *Merzbau* and the *Merzbarn* alongside pictures of other outsider architectures: beautiful and complex buildings made by people for reasons beyond, or in addition to, the usual desires for shelter and security, community and status. To see the *Merzbauten* in this context opened up fascinating possibilities and linkages.

I wanted to develop an exhibition that not only showed some material associated with the various *Merzbauten* but also which used them as a point of departure, taking their secrecy and removal from view as a theme, to explore

12

analogies of the way they crossed discrete orderings, and combined qualities of insider and outsider practice. My aim was to explore ideas of the construction of the secret and the closed world in different ways and to see how these might enhance the understanding of present day practice. *A Secret Service* focuses on artists whose work, in one way or another, takes on some of the qualities of 'the secret' where the usual exchanges or readings have been replaced with something more difficult and awkward; where the viewer's gaze is refused or made contingent and access is not a given.

Duchamp
p. 37, fig. 8
p. 39, fig. 9

We normally consider art and art practice in relationship to an audience, and in terms of one person's (the artist's) act of revealing and making visible for another person (the audience). Post-modern approaches to art production have generally (although not entirely) ignored the obscurities of Marcel Duchamp's long concealed last work *Étants donnés* (1946–66) and the hermeticisms behind his piece *The Large Glass* (1915–23) to concentrate instead on the positioning of the audience and the context of the gallery as necessary parts of the 'contractual' exchanges that constitute an artwork. Meanwhile, more recently, practices linked to 'relational aesthetics' have focused on the discourses and dialogues that are opened up by the interaction of a work and its audience.

With the massive expansion in recent years of the art market, the construction of the audience as consumer has become central to mainstream understanding of art and its possibilities, not only in the commercial art market, but also in the arena of publicly funded institutional culture where audience attendance figures and ideas of 'access' are used – sometimes exclusively – to assess the success, or otherwise, of events and initiatives. In view of this it seems that the polymorphous and various relationships that can exist between an artwork and a viewer have been reduced to no more than a mercantile exchange between producer (artist) and consumer (audience). At a time when it is increasingly difficult to draw a line between the commercial and public sectors of the art world or identify any territory – cultural or otherwise – that capital cannot invade, practices that suggest models outside those of utility or commodity take on a particular interest. Despite the visible success of contemporary practice – the art fairs, new museums and glamour – there is a strand of anxiety in contemporary art. It no longer knows quite what it is *for*. The previous engagement of the avant-garde with the 'political' has been repackaged as radical chic. The ideological underpinnings that allowed the possibility of agency and effect in the real world have melted into air. Is the function of art to be entirely subsumed in providing a circus for the rich, or constructing a new academy?

Yet as the *Merzbau* suggests, there are other approaches where the relationship of the work to the audience is complex and problematic and might refute or delay the normal articulations. What does it mean when the world that a work is engaged with is removed, in one way or another, from the audience's view? How are we positioned (and how do we feel) when the work has come into being without any idea of it entering into an exchange with us? How can the 'social' (and/or the art world) accommodate or understand the work that has withdrawn itself? And what takes place when – as in this exhibition, which situates work made for private consumption in a public context – one enters the influence of the other?

There is a generative logic at play in many of the works in *A Secret Service* where cosmologies are developed and mapped. These are often expressed in terms of the paranoid, the utopian, the visionary and the counterfactual. Seen as marginal they offer ways of reading the world (and readings of the world) outside more 'rational' models. Artists may seek connections to the hidden areas of a polity or a society in terms of the conspiracy, the secret or the magical. Sometimes these practices may seem to leave the realm of art behind and venture into a psychopathology, but it is this refusal of normal boundaries and definitions that gives them much of their power and interest. Certainly their ambiguous position between art and life recalls previous roles and functions for art that have become obscured and are often dismissed.

These approaches and practices have particular resonance at a time when ideologies and methodologies linked to Enlightenment Rationalism are increasingly challenged and eroded. We are witnessing all sorts of strange returns: supernatural systems and narratives from pre-modernity, belief in conspiracy and miracles. The most visible opposition to the Western model is seen to be no longer from Communism but from Radical Islam: mystical belief systems centred on canonical law, supernatural belief and miraculously revealed truth. In a 2003 poll taken in the United States for Rupert Murdoch's *Fox News*, 92 per cent of those questioned believed in the existence of God. Another survey in 2000 revealed 84 per cent of the correspondents believe that miracles 'are happening today'.[6] The best-selling book of recent years, *The Da Vinci Code*, is about the secret hidden for centuries by the Church regarding the succession of the bloodline of Jesus. Many people consider this to be fact wrapped in fiction. Fifteen per cent of respondents to the *Fox News* survey believe in Darwin's theory of evolution, but 50 per cent hold that the Biblical account is largely correct. This is the matter of the contemporary world.

As a parallel to this interest in the irrational within the art world there has recently been a return of interest in the figure of the 'outsider artist'. This may, in part, be a result of an attempt to bring new products into the market place, or it may be a symptom of the return to romantic essentialism. But another element lies in the challenges that these practices present to our current understanding of the roles and positions of art and its activities. Some, like the opaque practices of Oskar Voll (explored in this book by Roger Cardinal), return us to the profound mysteries of symbolic expression. Others converge with contemporary approaches and interests.

Voll
pp. 111–13
cats 40–42

In recent years, Henry Darger has become one of the most visible 'outsider' artists owing to the way that his works anticipate or prefigure many contemporary approaches and concerns; the exhibition, *The Disasters of War*, curated by Klaus Biesenbach, showed his work in conjunction with that of the Chapman brothers.[7] During Darger's life, however, his 15,000-page novel, *The Story of the Vivian Girls, in what is known as the Realms of the Unreal, of the Glandeco-Angelinnian War Storm, Caused by the Child Slave Rebellion* (possibly the longest work of fiction ever written), remained unread, and the artworks that illustrate the text unseen. Darger's productions came to view when Nathan and Kiyoko Lerner, the then owners of the boarding house where Darger had lived for over 40 years, started to clean out his room after he had been moved to the nursing home they had found for him. The drawings

are of the richly imagined and described world of the seven Vivian Girls –
hermaphrodite Shirley Temple-esque figures, represented with male genitalia –
as they seek freedom from the atheistic nations that have enslaved all children.
The illustrations show the progress of the armed struggle between the girls
and the armies of the atheistic and Christian nations, the latter having come
to the aid of the girls' rebel army. This narrative of flight and war, violence and
destruction, is painstakingly represented in collage and watercolour. Under
these delicate, beautiful surfaces, the works have a profoundly uneasy pulse.

Darger's work has been variously identified as the output of a sexual
criminal, a victim of abuse, a traumatised innocent, or all of these combined.
Certainly it expresses an uneasy dialogue of conflicted urges in the artist's
psyche. The drawings are disquieting because we cannot identify a function
for them. We can only presume what, or who, they were made for. Are they
just expressions of disturbed fantasy as suggested by Lyle Rexer who imagines
Darger 'confronting the spectacle of what he had created and indulging in
conflated auto-erotic pleasure'?[8] But Rexer's lonely onanistic projection does
not take Darger's Catholic faith into account. Kiyoko Lerner recalls that one
day Darger lost a favourite painting: 'Finally he threatened God. If God didn't
return it, he, Henry Darger would join the enemy force in the Realms of the
Unreal. So sure enough, General Darger joined the Grand TK Army, and it
started to win the war…'.[9] The works can be seen as part of a complex web
of expression and communication between Darger, his compulsions and the
invisible audience of his all-seeing God.

When I was a performance artist in Newcastle in the 1980s, Tehching Hsieh's
work existed only as rumour. I was never certain that the piece in which he
clocked-on every hour, on the hour, for a year, did not belong to the realms of
art-myth and urban legend (along with the amputation machine built to reduce
its maker by degrees in a public suicide or Rudolph Schwarzkogler's castration
as a performance). Hsieh, however, did perform this and a number of other
extraordinary works as largely private experiments with limited but rigorous
documentation and a small number of witnesses. His clocking-on work, entitled
One Year Performance, 1980–81 (1981), was recorded in a short film of single
frames taken at each clocking-on, and included signed statements by Hsieh's
assistant and the clock cards themselves. In 1978, Hsieh lived for a year in a
cage built inside his studio. He was fed each day and his waste was removed.
An audience was occasionally allowed in to watch. When Hsieh elected to live
without making art for a year (*One Year Performance, 1985–86* (1986)), and then
made an action that lasted for 13 years, the audience was more or less entirely
removed from the operations of the work. Instead, there are only statements
saying that the act has taken place; the act has been withdrawn
from view into a private sphere. As with the *Merzbau*, Hsieh's performance
works were of the art world but at the same time removed from it, as their
internal logic obstructed any easy encounter with, or experience, of them.

Katarzyna Józefowicz's work *Games* (2001–03) is made up of hundreds and
hundreds of sheets of advertising material folded into small cubes and then
carefully stacked and arranged in the exhibition space. When our eye passes
over these sealed volumes we become aware that we are experiencing only
the residue of an extraordinary labour, a labour whose purpose we cannot

quite comprehend despite the fact that the outcome is staring us in the face. The work becomes a barrier that, whilst bearing witness to these unseen actions, simultaneously obscures them. Józefowicz often uses repeated actions to make her works. *Untitled* (1994) consists of narrow strips of newspaper stuck together, then carefully wrapped around a spindle into vast wheels making the printed information illegible. For *Carpet* (1997–2000) she cut out thousands of figures from colour magazines and assembled them in serried ranks, each close behind the other, to form a massive field of small two-dimensional figures. In each of her projects the audience is made aware of a vast hinterland of effort: unremitting labour and infinite patience, the reasons for which remain tantalising. 'I have become a slave to building', the artist says, talking of the activity that drives her work, where 'she is a mere pawn in the expansion of matter'.[10] This ghost of excess labour has a destabilising effect when it comes to understanding. As in the *Merzbau*, it shifts our readings first into the pathological – the nervous tic, the Tourette's repetition – but then there seems to be a link to mystical practices, where one small act infinitely repeated in a small room in the artist's flat mortifies the flesh and loops the nervous system into patterns of its own making and brings new worlds into being.

Dream Mapping (1974) by Susan Hiller explores the relationships between the subjective worlds of group reality and the scientific and cultural world. A number of people were invited to sleep for three nights inside the fairy rings of mushrooms that grow in grassy fields and which have in folklore, as their name implies, a role as a transition between the everyday world and the fairy realm. To sleep in one is to open up the possibility of travelling into that other world, perhaps, as folktales have it, never to return. In many different cultures – Ancient Greek, Native American and in European traditions – specific places are identified as especially propitious for dreaming, and to go there for this purpose is known as 'incubation' (from the Latin 'incubare', 'to lie upon'). The dreams that take place are considered to be of special significance, providing divinely inspired insights or cures. Incubation was practiced by members of the cult of Asclepius, and is still used in a few Greek monasteries.

Hiller
see opposite fig. 4,
p. 69, fig. 13
pp. 70–71, cat. 20

Dream Mapping required that each morning the sleepers would map the shape and memories of their dreams in a notebook. These maps were then superimposed, making a survey of the dream space(s) that the sleepers had variously explored, to test if there was co-incidence, resonance or a shared event. This search for a collective architecture of these hidden, subjective spaces echoes the desires of twentieth-century psychology and its articulations and representations of the human psyche, as well as the earlier expressions of religion with its mappings of heaven and hell. Freud was certain that he could locate the position of the superego in the volumes of the brain, and the medieval monk had a physical location for paradise.

Dream Mapping is a collective exercise in data collection that refers both to Western science and to traditional approaches in other cultures where dream experiences are shared. It momentarily places dream experience into the matrix of Western research to suggest possibilities outside the normal parameters of science, but does so through an approach that is poetic rather than clinical. The work also quizzes the constructions and operations of the audience in art, specifically in live art and performance. In *Dream Mapping*,

fig. 4 Susan Hiller, *Dream Mapping: Dreamers in Field, Purdies Farm, Hampshire*, 1974

the sleeper/map-maker transcends the usual relationship between artist and viewer. Here the roles are conflated, the map-maker is both the generator of part of the work (the dream and the mapping) as well as the audience: the person to whom the dream happens. Unlike much conceptual practice of its time, *Dream Mapping* focuses on the visual and the drawn as a means to bring back into view the non-verbal. This material that is not yet shaped by language is more problematic and resistant to articulation. Hiller's use of it is never entirely opposed to rational post-Enlightenment belief systems, or a blunt reflex of the post-modern equivalent, but instead continually tests our certainties and expectations that these systems can fully map the universe.

At the beginning of the twentieth century, American writer and researcher Charles Fort started collecting 'anomalous data'. This was data that did not fit with any of the dominant narratives of scientific methods of the day, so was usually ignored or marginalised. These areas cover crypto-zoology, UFOs, OOPArts (or 'out of place artefacts'), levitation, telepathy, and so on; things that Fort recorded to reveal and test the limits of orthodox modellings.

Artist Jeffery Vallance is a regular contributor to the *Fortean Times*, the publication that continues Fort's work today. Vallance plays with tales of popular mythology, which he combines with his own invented elements, such as the stain left on the wrapping by the frozen supermarket chicken, 'Blinky the Friendly Hen'. His practice celebrates and investigates the extraordinary creativity of mythic, folkloric and religious drives in American cultures. He traces and documents manifestations of the spear of Longinus – reputed to have pierced the side of Christ – which became the 'spear of destiny' in Nazi mythology, luridly described in many popular books about the arcane underpinning of National Socialism. Fakery and the 'real' is a central concern in Vallance's work, and he explores what happens once powers are invested in an image or an object in such a way that they become fetishistic or charged, as for example in icons or reliquaries where the representation itself takes on religious meaning. His deranged tales of satanic clowns and the outline of George Washington found in the Shroud of Turin underline their dark chthonic possibilities and speak of the interweaving of faith and politics that we see so clearly in modern day America.

In a clever articulation of paranoia about the power and operations of 'the State' that is shared by both the right and the left wings of the political spectrum, Vallance's *My FBI File* (1981) shows us information that the FBI had collected on the artist. Originally a secret file meant only for the eyes of the Federal Bureau of Investigation, Vallance was able to gain access to it through the Freedom of Information Act, although some of the information contained in it is still censored. It describes the sort of behaviour that, as individuals, we might be happier to hold only in our own recollection, rather than it coming to the notice of the State or, through its conversion into an artwork, the audience of an exhibition.

The medicine drawings by Ethiopian artist Gedewon are from the Ethiopian talismanic tradition, and take changed states as their condition, cosmologies as their matter, and spirits as their audience. They play a complex and layered game with actual and supernatural vision appealing to different orders of the world and simultaneously operating as art objects in a conscious and modern sense. Jacques Mercier writes the following of talismanic art:

Vallance
pp. 107–09
cats 37–39

Vallance
p. 118, cat. 43

Gedewon
pp. 65–67
cats 17–19

Talismans are not illustrations of prayer but act by themselves on the spirit through the eyes of the possessed person. Gedewon situated his talismans firmly in the contemporary world, describing them as 'study and research talismans'. He filled a notebook with drawings of talismans for me in 1975 [...]. He set out the classic themes of talismans to the Names of God and of certain angels [...].'What you have to do', he says 'is to ask the sick person to describe the contacts and visions he had when he fell ill, and to inscribe these colours and forms in the talisman, accompanied by suitable Names of God. The demons take on changing appearances: bees, flies, birds, arms, eyes, flowers, stones, etc.' The aggressive spirit, seeing its own appearances in the talisman, will cry out and flee, as through burned. By proceeding in this way, he is prevented from gaining access to the human body. The talisman is a prohibition. And its form has to do with a strategy of tension. Gedewon's talismans are surfaces that proliferate to infinity, frontiers that bring into being spaces that they simultaneously separate.[11]

Modern Western medical ideas and authorities increasingly threaten the body of thought and beliefs that animates these drawings.

Nelson
pp. 94–95
figs 15–16

Mike Nelson uses the fictions of the secret as a core focus of his work. His complex, labyrinthine installations act as the settings and *mise-en-scènes* for narratives that we can only guess at as we are led from one room to another. These constructed, enclosing worlds are a direct descendant of the grotto-like spaces of Schwitters' *Merzbau*, but with the essential difference that here we can enter and leave as a viewer, trying to construct stories and links from the architectures and artefacts we encounter. The narratives that the works evoke are more of film and literature: where the psyche described is that of a player or character rather than the artist. We can imagine the *Merzbau* itself appearing as a filmic scenario in a Nelson work, or indeed Darger's room – the hidden environment of a mad artist.

Darger
pp. 2–3, fig. 1

A room in Nelson's work, *Triple Bluff Canyon* (2004), combines a close reconstruction of the artist's studio with a video projection of an American right-wing conspiracy theorist to suggest the workshop of a fabulist. However, it is a fabulist using the events of the 'real' world for their narratives and seeking hidden connection in the body politic. It is here that Nelson's work achieves its impact for in one way or another it always alludes to particular social or political realities – the blind alleys and mazes distantly echoing the operations of power upon the subject. These are worlds where individuals and groups have to retreat and hide in contingent spaces that are found outside, or hidden behind establishment structures. For the 2004 São Paulo Biennale, Nelson built a flawless extension of the white curved surfaces of the exhibition space. The construction concealed hidden areas that the visitor was able to penetrate and in which they stumbled upon the abandoned relics of Condomble rituals left behind by an absent population, who had either concealed itself within, or fled the gallery. The audience was presented with clues and traces of actions and activities and, by implication, complex belief systems and

understandings of the world that they now had to make sense of in the same partial way that an archaeologist or a private eye might.

Ritual is invoked too in Paul Étienne Lincoln's *Purification of Fagus sylvatica var pendula* (2001), which consists of the paraphernalia and documentation of a rite that took place in parkland in New York City at the stump of the oldest Weeping Beech in America. This plant was brought to the USA by Samuel Bowne Parsons, a Quaker and nursery man, in 1847 from Belgium where he had been travelling in search of exotica. Every Weeping Beech in America is descended from this single tree which itself died and was cut down in 1997. This object and history become part of Lincoln's investigation into the origins and narratives of human memory. The components of the piece, and the enacted ritual involving the processes of extraction, distillation and crystallisation, draw on the languages and intentions of alchemy: the transformation of materials and essences and the revealed understanding of the world as a text, as a realm of powers and correspondences which, if properly understood, will allow man to take on transformative power. Beechwood smoke is distilled to obtain wood creosote, which has preservative and antiseptic qualities. When this undergoes another purification process it yields a crystal of a substance named guaiacol, an inducer of nerve growth. Lincoln's work recalls Duchamp's borrowing of alchemical approaches in *The Large Glass*. There, the fact that the imagery illustrated a text and symbolic language, which itself was hidden and nonsensical, was crucial. That the text turns out to be a fiction is of itself no concern. This was also true for the alchemists, whose search for transformation and understanding underpinned the first developments in physics and chemistry. A delight in systems and cosmologies is a central theme in Lincoln's practice, where they are taken from one discipline and applied to another. This perhaps reaches its apogee in *New York Hot and New York Cold* (1987 and ongoing), where the entire city and its history over the last 60 years is reconfigured as a vastly complex mechanical closed system of electrical generators, pumping systems, sirens, musical organs and heat circuits.

Lincoln
pp. 85–87, cat. 27

The PAN Museum Project (1999) by Joachim Koester and Adrian Dannatt documents the studio and the apartment of the artist Pietro Antonio Narducci. Narducci, whose cosmological works can be seen in the images here, was not an 'outsider' in his awareness of the narratives of art, nor indeed in his technical training, but merely in his relationship to the art world: terms that history and circumstance have (momentarily) determined, rather than the artist in a conscious or unconscious act. As outlined in the text by Adrian Dannatt that is a component part of the work (bound into this book), made in association with Joachim Koester, Narducci had been a member of the New York School and a founder of Abstract Expressionism but failed to achieve the acclaim of some of his contemporaries. Rather than allowing this to discourage him, he continued making his work, but in private. After his death, the rooms of his apartment and the work he abandoned in it were maintained by his daughters, as a memorial, and in the unvoiced expectation that the life they represented may eventually make the transition from the unknown to the known: the 'undiscovered' being a central theme both in the hopes of artists and in the mythologies of the art world and market. The actions that the rooms provided a context and a setting for – and the histories and desires that motivated those actions – have left only

Koester
pp. 81–83, fig. 14

a residue of the baffling evidence presented to our eye. This invites us to attempt a plurality of impossible and poignant reconstructions that makes us aware of the gaps and lacunae between the material presented to the eye and the vastness of that which we are attempting to retrieve and re-animate – aspiration, work, an entire and complex life – and the mechanisms of love and loss as manifested in the preservation of the apartment by Narducci's daughter.

Some of Roberto Cuoghi's activities occupy the electric territory between the aesthetic and the pathological. His practice uses diverse media – video, comic book illustration, painting and drawing – in a multi-faceted body of work that explores ideas and codings of representation. At the core of the practice lies a work – or rather an action – that never fully reveals itself, but which informs and animates the artist's activities; an action that was scarcely documented and exists more as a rumour that constantly resists interpretation. In 1998, in his 20s and a student at Milan's Accademia di Belle Arte di Brera, needing to avoid some people in his life, Cuoghi put on weight (increasing his bulk to over 20 stone (127 kilos)), dyed his hair grey, changed the way he dressed and took on the appearance and mannerisms of a man in his mid-60s. This transformation was maintained for over seven years, a period in which he effectively erased his young self and became his father. He even wore some of his father's clothes and started to develop the heart problems experienced by overweight men in their 60s.

Those who saw this act were the people with whom Cuoghi interacted in day-to-day life. When he was photographed, it was as a snapshot, rather than as an image for a gallery wall. At the same time, Cuoghi did not actively deny the possibility of this act being seen in the context of art, nor did he actively position it as such. In an interview with Massimo Grimaldi he was asked:

> I believe that your work, like mine, has been subjected to excessive simplifications, or true misunderstandings. Could you tell me about some particular errors and indicate what should have been said instead?

To which Cuoghi replied:

> I should have prepared something informing people about the fact that I had put myself in the guise of a middle-aged man, with my father's clothing, with tastes and manners that were not my own but would become my own. They asked me to organise material for the occasion of the fourth edition of *Manifesta*, in Frankfurt. The idea was to make an official presentation of the operation, but that wasn't my idea. A change of appearance is for those who cannot know about it. For me, having to document it to made it seem like an artwork isn't even a compromise, because it truly makes no sense at all. So I've never documented anything. I just left it up to others, and this has meant that meanings have been mixed up, information has been confused, and I have had no control over it.[12]

Cuoghi's lenticular print, *Untitled* (2005), is one of the few works that relates to this seven-year period. The video work, *Foolish Things* (2002), has its genesis in the narrative of the transformation and its relationship to the art world but the work erases and obscures the act behind the footage of a model of a rising sun.

Cuoghi
p. 55, fig. 12

The work of Sophie Calle brings to view the movements of the individual in the city. Famously, Calle has taken the operations of the private eye – a character known through fiction – and applied them to the production of her work. She has gone 'undercover', followed individuals and collated information about them. The actions that would normally be considered part of the private anonymous sphere have been made visible and mapped through space, and these mappings then opened to the public view. The private world that is revealed is not only that of the person who is followed but also that of Sophie Calle. Desires and drives that would normally be held close to the individual, seen as the interior workings of a private pathology, are externalised as a documented action.

In *Suite Venitienne* (1979), Calle tailed a man she had met at a party in France all the way to Venice, taking photographs and keeping a notebook detailing her pursuit and her observations. In *Address Book* (1983), she found an address book in the street and copied its contents. She then contacted those listed in its pages and compiled a dossier of information on its owner, which was published in a newspaper. In *The Hotel* (1981), she took a temporary job as a chambermaid, exploiting the access this gave her to the hotel's rooms. Alone in the rooms, she explored guests' luggage, documented their possessions and went through their wastepaper baskets and bathroom cabinets to glean information on them – an echo of Schwitters' thefts and relocations. Her discoveries and conjectures form the matter of the photo-panels of her works. The work poses difficult questions about the relationships between the private and the public, and between the spheres of art and the pathological. If Calle's actions were not somehow dignified or authorised by the world of art, could we tell them apart from the everyday violence of stalking? To what extent are we made complicit in actions that we would otherwise find very problematic? As 'art', Calle's work is to some extent dignified by the aura of personal expression and systematic exploration. But what are the dynamics and history of this validation and how would we react if, as in the case of Jeffery Vallance and his *FBI File*, an apparatus of the State had assembled this material?

Calle
pp. 51–53
cats 8–10

Mark Lombardi's detailed and beautiful drawings trace overt and covert relationships between multinationals, individuals, criminals and politicians that constitute the operations of the State and the public sphere. The drawings reveal the secrets and linkages that caused the collapse of the Vatican Bank, enabled the Iran-Contra dealings and produced the Whitewater scandal. They outline the relationships between George W. Bush and Harken Energy or Banca Nazionale Del Lavoro, Ronald Reagan, George Bush, Margaret Thatcher, and the arming of Iraq. They show us how the money was moved and where it went. 'At some point in my development', says the artist, 'I began to reject reductivist approaches in favour of one capable of evoking the complexity, venality and occasional brutality of the times. What emerged was a study of "irregular" financial transactions, with special emphasis on those undertaken in secret by select groups of influential yet silent partners.'[13] Although rooted entirely in

Lombardi
pp. 89–91
cats 28–29

the 'real world' and exhaustive in their research and their accuracy, the works speak also of compulsion and paranoia. All Lombardi's source material came from books, newspapers, publications and magazines as he was working in the days before the internet. These he found, read, cross-referenced and collated on hundreds of file cards, which he stored in cabinets in his studio. This obsessive archiving then became the engine for the production of the work:

> After a careful review of the literature I then condense the essential points into an assortment of notations and other brief statements of fact, out of which an image begins to emerge. My purpose throughout is to interpret the material by juxtaposing and assembling the notations into a unified, coherent whole. In some cases I use a set of stacked, parallel lines to establish a time frame. Hierarchical relationships, the flow of money and other key details are then indicated by a system of radiating arrows, broken lines and so forth. Some of the drawings consist of two different layers of information – one denoted in black, the other in red. Black represents the essential elements of the story while the major lawsuits, criminal indictments or other legal actions taken against the parties are shown in red. Every statement of fact and connection depicted in the work is true and based on information culled entirely from the public record.[14]

cat.1 The Speculative Archive, *In Possession of a Picture*, 2005 (detail)

MGM Grand Hotel, Las Vegas, Nevada
Karim Koubriti, Ahmed Hannan, and
Farouk ali-Haimoud, 2000?

The Speculative Archive
see above cat. 1,
pp. 104–105
cat. 36

The Speculative Archive expands this tracing of the secret from the social and political sphere into the electronic. It focuses on the ways that government and intelligence services seek to control information through constructions of secrecy and how these are both enabled and denied by the public archive, the electronic universe and the internet. *In Possession of a Picture* (2005) examines recent cases in which people have been stopped and detained because they were videotaping or photographing particular sites in the USA (bridges, casinos, banks, landmarks, tourist attractions, etc.), or in which people were detained for

other reasons and then found to be in possession of videotapes or photographs of particular sites.[15] Seemingly anodyne views have been determined to be sensitive and of interest to 'enemy' eyes. They have been made, in one way or another, secret. They have been articulated in a (new) narrative of terrorism, threat and security that we have no access to, but which inscribes a world parallel to the one that we inhabit – and inflects it – but to which we have little or no access. It is a world narrated by the security forces to whom we may be deemed a 'person of interest' or potential terrorist. In the work, this (missing) image is represented through a black square, under which the name of the person who was taking the unseen photograph is written. It is twinned with a representation of the same building or sight that The Speculative Archive has sourced from the World Wide Web or the public record, so locating these images as a meeting, or fault-line, between worldviews and hidden narratives.

At the same time that Western Rationalism is fading, the State seeks increasingly to remove things from our gaze, to pull more and more of its activities back into the shadows. This increased currency of the very idea of the secret, the unknown and the unknowable, and its spread between categories – spiritual, political and social – means that the autonomous areas that we have enjoyed as individuals – personal, subjective and secret – are increasingly interrogated by the social and the politic. The practices in *A Secret Service* may suggest models and methodologies for engaging with, reflecting or understanding these discourses, their operations and the realities that they are shaping.

Richard Grayson

1. Kate Steinitz, *Kurt Schwitters: A Portrait from Life*, University of California Press, Berkeley, 1968, p. 91.
2. The very secret caves were probably never seen by anybody except Walden, Giedion and Arp. See Webster, op cit., p. 222.
3. Jerome Rothenberg (ed.), translated by Pierre Joris, *Kurt Schwitters: Poems, Performance, Pieces, Prose, Plays, Poetics*, Exact Change, Cambridge, 2002, p. xx.
4. Webster, op. cit., p. 84.
5. François Bazzoli, *Kurt Schwitters*, Images En Manoeuvres Editions, Marseilles, 1991, p. 60.
6. www.foxnews.com/story/0,2933.99945,00html
7. *The Disasters of War: Francesco de Goya, Henry Darger, Jake and Dinos Chapman*, exhibition catalogue, Kunstwerk, Berlin: July – November 2000; PS1, New York: November 2000 – February 2001.
8. Lyle Rexer, *How to Look at Outsider Art*, Harry N. Abrams, New York, 2005, p. 123.
9. Kiyoko Lerner in conversation with Klaus Biesenbach (ed.) in *Henry Darger: Disasters of War*, KW Institute for Contemporary Art, Berlin, July 2004.
10. Magdalena Ujma, 'Sweet Captivity' in *The World May be Fantastic*, Sydney Biennale, Sydney, 2002, p. 110.
11. Jean-Hubert Martin in *Art that Heals*, Apexart Gallery, New York, March 2002, http://apexart.org/exhibitions/martin.htm
12. Roberto Cuoghi interviewed by Massimo Grimaldi in M. Grimaldi, *13 E-mail Interviews*, PVC, 500 bks, 2005, unpaginated.
13. Mark Lombardi, Press Release, http://www.pierogi2000.com/flatfile/lombardi.html
14. Mark Lombardi, Artist's Statement, 1998, http://www.pierogi2000.com/flatfile/lombardi.html
15. http://www.speculativearchive.org/content.php?sec=projects&sub=installation_posses

cat. 2 Kurt Schwitters, *Merzbau (detail: grand group)*, c.1932

Overleaf, **cat. 3** Kurt Schwitters, *Merzbau (detail: stairway entrance side)*, c.1932

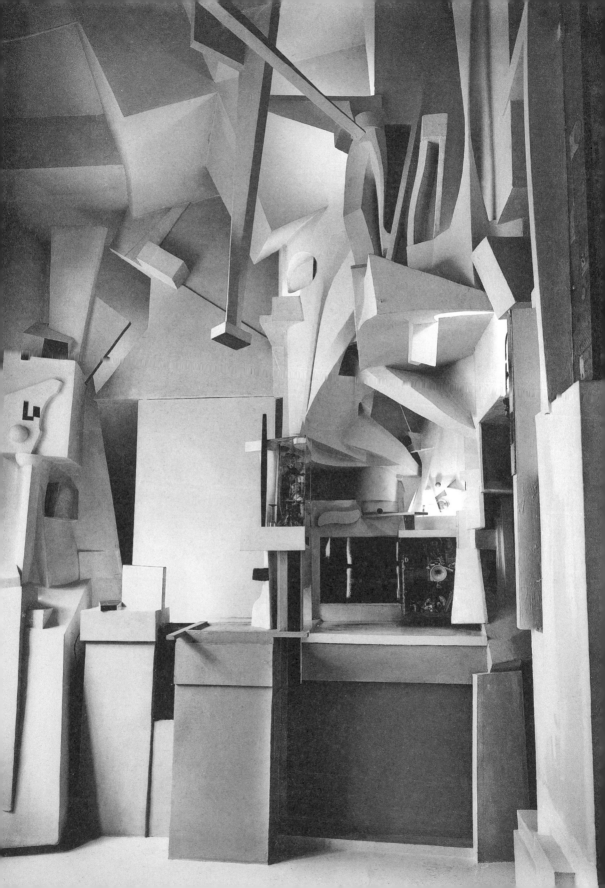

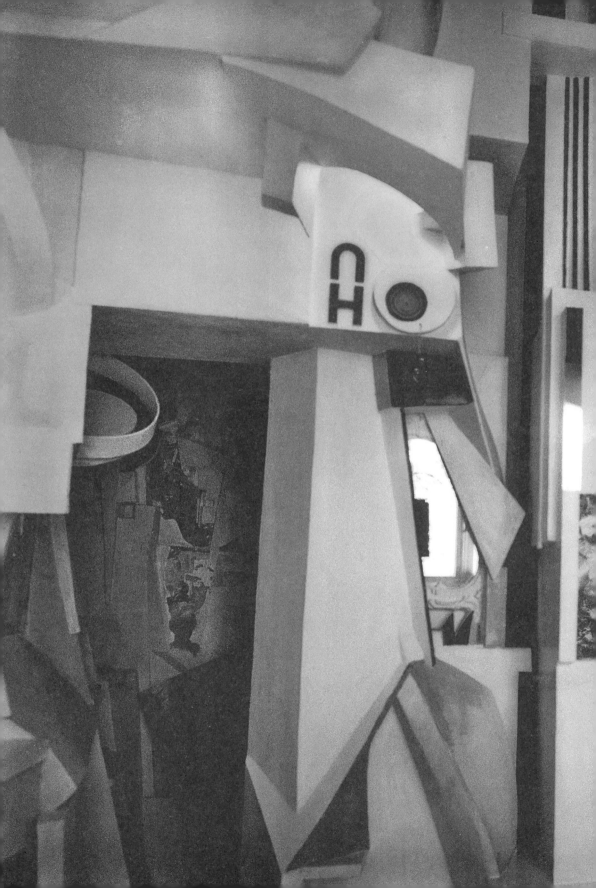

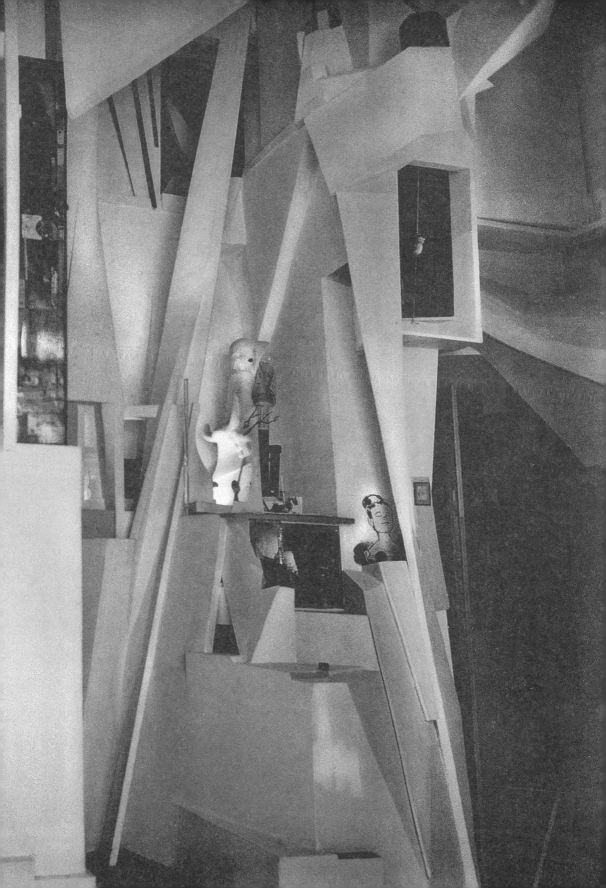

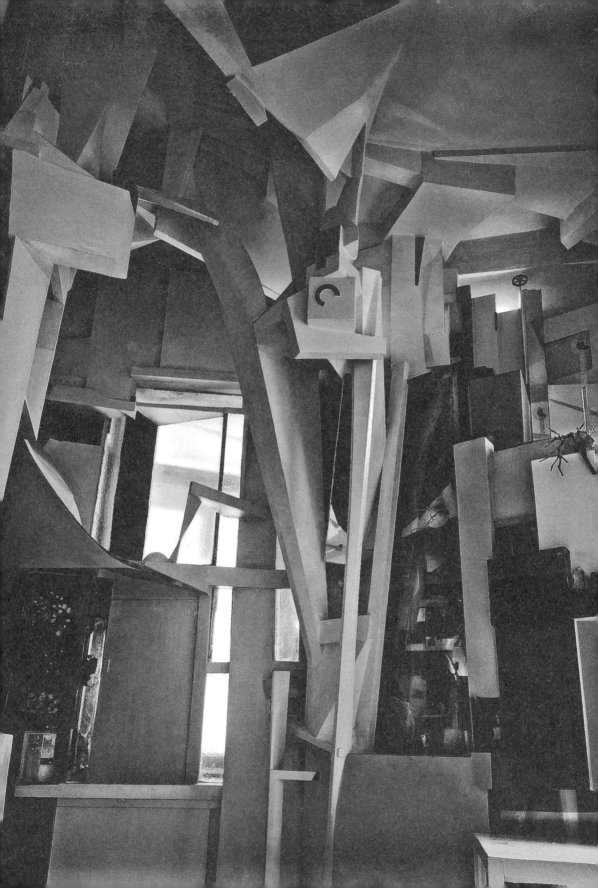

OUTSIDE IN AND FRONT TO BACK:
TALKING ABOUT THE WEATHER FROM BEYOND THE GRAVE

Enjailed air steeps
The murder overdomes blood
If only I could shard these walls!
O this glow of the embracing wall!
Jail unifies –
Blood jails –
Blood steeps –
[…]
Green
Shot –
Who shoots?
Blood?
Sulfur –
Blood –
Fear –
Chase –
Fly –
Scream –
Blood grins – yellow – bright – yellow
Yellowgreen
Blood grins brightsulfuryellowgreen
If only I could wash the green blood!
[…]

from K. Schwitters, *Das Grünes Kind*, quoted in E. Burns Gamard, *Kurt Schwitters' Merzbau: The Cathedral of Erotic Misery*, Princeton Architectural Press, New York, 2000, p.51.

Just as much twentieth-century history appears to have been reliably documented, so too do the facts of Kurt Schwitters' life. Born in Hanover in 1887, heir to a modest property fortune, from an early age Schwitters was certain of his vocation. In 1904 he enrolled in the Dresden Kunstakademie where he studied academic painting until the outbreak of the First World War in 1914. Diagnosed epileptic, he was exempted from military service and spent the war years experimenting with impressionist, expressionist, abstract and figurative painting styles. In 1915, against his wishes and at the behest of his parents, he was married to his cousin Helma Fischer. Their first son Gerd was born two years later; he lived for just eight days.

The years 1918–19 were as cataclysmic for Germany as they were for Schwitters, whose work from this time contains abundant clues to his sorrow at the death of his child. With the close of the war and the fall of the Wilhelmine Empire, the country plunged into political turmoil and near civil war. In January 1919 the co-founders of the German Communist Party, Rosa Luxemburg and Karl Liebknecht, were murdered by anti-democratic Freikorps officers, crimes that together with the notorious 'Feme' murders – a series of lynchings of Republican politicians by right-wing groups – were never punished. 1919 also saw the signing of the Treaty of Versailles; its terms designed to humiliate and paralyse the vanquished with the burden of massive

reparation costs.[1] The violence and chaos of the time was more immediately felt by Schwitters, who had escaped the trauma of military combat. *Das Grünes Kind* is among his first sustained literary works; written at some imprecise moment during this nightmarish period, its awkward syncopated language could be likened to the ranting of a somniloquist trying to break into consciousness from a bad dream. The poem opens with the image of a place of incarceration: a jail that both protects and suffocates, and carries an atmosphere of claustrophobia, mimicking the author's frame of mind. The exclamation 'If only I could shard these walls' expresses a desire to shatter and break free but also to defensively reinforce and retreat inwards, while the repeated reference to blood suggests not only the bloodshed that literally and psychologically imprisons the guilty, but also the intractability of blood ties. The more general horror of Germany's defeat, condemnation by the outside world and consequent introversion are conflated with personal horror – the loss of the 'green child' of the poem's title.

Just as the spatial metaphor in *Das Grünes Kind* collapses interiority with exteriority, so Schwitters' language propels meaning forward and backwards. Blood does not *seep*, but *steeps*; political catastrophe and personal tragedy infect and augment each other. The precise use of colour in the poem operates in a similar way: blood-red is countered by its complimentary green – on the one hand indicating sickness and putrifrication, but also a traditional signifier of romance, renewed life and energy. On 19 November 1918 the Weimar Republic was founded and for the first time in its history Germany was constituted as a democratic nation state. The same day, Schwitters announced the birth of Merz, a one-man movement of his own invention, open and available to all. The fact that the actual date of the founding of the movement was retrospectively *merzed* (i.e. changed) by the founder to coincide with the establishment of Weimar emphasises Schwitters' identification of Merz with the lifting of political, social and moral constraint:

> I felt myself freed and had to shout my jubilation out to the world.
> Out of parsimony I took whatever I found to do this, because we are
> now a poor county. One can shout through refuse, and this is what I
> did, nailing and gluing it together. I called it 'Merz', it was a prayer
> about the victorious end to the war, victorious as once again peace
> had won in the end; everything had broken down and new things
> had to be made out of fragments.[2]

It is not known if the word fragment that gave its name to the Merz movement was extracted from the phrase *Privat Commerzbank* with paradoxical intent, but the fact is that in spite of Schwitters' strident insistence on the celebratory openness of Merz, his most significant Merz work – the *Merzbau* – was also his most enigmatic.

The *Merzbau*, or 'merzbuilding', was a combination of collage, sculpture and architecture which began as a construction in a corner of Schwitters' studio and, over a period of some 20 years, expanded in all directions until it occupied much of the house at 5 Waldhausenstrasse that he shared with his extended family. The construction filled rooms with grottoes, caves and shrines dedicated to

Schwitters
pp. 25–28
cats 2–4
pp. 97–101
cats 30–34

cultural and historical figures and texts – Martin Luther, Goethe, the ancient, epic poem *Das Nibelungenlied* – as well as to contemporary events (to which I shall return later) and to Schwitters' many artist and architect friends, amongst them Mies van der Rohe, Hans Arp, Sophie Tauber Arp, Max Ernst, Piet Mondrian, Naum Gabo, Hans Richter, Theo Van Doesburg and Hannah Hoch.

To the few who saw it, the *Merzbau* was a confounding riddle. To those living in its immediate vicinity it was a closely guarded secret. Not only did Schwitters whitewash the windows of the house to prevent curious neighbours and passersby from looking in, but when the work did expand and rupture the bounds of the building that contained it, it did so beyond the view of all but its inhabitants; bursting upwards through a skylight and out onto the roof and descending via a specially constructed spiral staircase into the cellar where excavations unearthed a concrete cistern filled with water and draped with strange subterranean lichens.

But the most perplexing characteristic of the *Merzbau* is that while Schwitters clearly considered it his quintessential creation, his *Lebenswerk*, or 'life's work', very little about it is clear or unambiguous; Schwitters' accounts of it are sporadic and contradictory and photographic documentation is sparse and inconsistent. If the *Merzbau* was still around to explore and consult, none of this would matter. But it isn't. Together with the house at 5 Waldhausenstrasse and the innumerable Merz collages and sculptures that were stored there, it was completely destroyed in an Allied bombing raid on Hanover in 1943. Today, the *Merzbau* exists only in the imaginations of those convinced of its importance, returning it to its true original status as a private fantasy world.

Duchamp
p. 37, fig. 8
p. 39, fig. 9

Together with *Étant donnés: 1 la chute d'eau, 2 le gaz d'eclairage (Given: 1 The Waterfall, 2 The Illuminating Gas)*, 1946–66, the installation that Marcel Duchamp developed in secret in his attic studio on Manhattan's West 14th Street during the last 20 years of his life, and which was discovered only after his death in 1966 – Schwitters' *Merzbau* is one of the most haunting puzzles of modern art; a work whose code is further scrambled with each successive attempt at interpretation.

It is curious to compare Schwitters and Duchamp, not only in respect of their most secret and substantial works, but also because they have much in common: a shared enthusiasm for verbal tricks, palindromes, nonsense and *double entendre*; a commitment to the transfiguration of everyday objects and images through juxtaposition and naming; a fascination with alchemy and hermeticism; and a female patron alter ego who appears early in their development – Duchamp's androgynous Rros Sélavy, whose name plays with the sounds of the French phrase *eros c'est la vie* (eroticism is life) and Schwitters' ideal mistress, Anna Blume, whose palindromic qualities are exalted in Schwitters' celebrated poem *An Anna Blume*: 'One can also read you from the back ... You are from the back as from the front; A.N.N.A.'[3]

Tantalisingly, no detailed account can be found of Duchamp's 1929 visit to 5 Waldhausenstrasse. The *Merzbau* provoked extreme responses and Schwitters' tendency was to show it only to trusted insiders. Nevertheless, given the two artists' shared association with Dada and the fact that on the occasion of Duchamp's visit he was accompanied by a committed supporter

of Schwitters' work – the American collector Katherine Dreier – it seems likely that Duchamp was invited to explore the *Merzbau*. If this is correct it is possible that *Étant donnés*, which bears strong structural and thematic similarities to the *Merzbau*, and was not begun until 1946, might have been inspired in part by Schwitters' creation.

What might Duchamp have seen had he entered the *Merzbau* in 1929? Two years after the French artist's visit to Waldhausenstrasse, Schwitters published the first comprehensive description of the construction,[4] elaborating in particular on the nature and content of its numerous shrines – *The Cave of Hero Worship, The Puppet Hole, The Gold Grotto, The Goethe Grotto*, and so on. In particular, two of these grottoes are striking in relation to Duchamp's *Étant donnés*: 'The Sex Crime Cavern with an abominable mutilated corpse of an unfortunate young girl painted tomato-red and splendid votive offerings'[5] and the *Grotto of Love*, for which the most detailed description is reserved:

> *The Grotto of Love* takes up approximately one quarter of the base of the column; a wide outside stair leads to it, underneath in a long narrow corridor scattered with camel dung stands the Klossetfrau des Lebens (female lavatory attendant of life). Two children greet us and step into life; owing to damage only part of mother and child remain. Shiny and fissured objects set the mood. In the middle a couple is embracing: he has no head, she no arms; between his legs he is holding a huge blank cartridge. The child's head is twisted around and its syphilitic eyes are warning the couple to be careful.[6]

In order to get a more complete picture of the *Merzbau* it is worth turning to an eyewitness description from one of its few select visitors – Schwitters' close friend, the art critic Rudolph Jahns. Jahns' account focuses on the phenomenological experience of entering the structure:

> …there were grottoes of various types and shapes, whose entrances were not always on the same level. If you walked all the way around, you finally reached the middle where I found a place to sit, and sat down. I then experienced a strange enraptured feeling. This room had a very special life of its own. The sound of my footsteps faded away and there was absolute silence. There was only the form of the grotto whirling around me.[7]

Read together, these two descriptions evoke something of the atmosphere of the stifling, embracing jail in *Das Grünes Kind*. They also confirm the contradictory impulses at work in the *Merzbau*: first, the designation of disparate objects and events as sacred (the bringing in of the outside); second, the physical and metaphorical retreat from the external world to a place of silence and forgetting. Schwitters sometimes referred to his construction as *The Cathedral of Erotic Misery* (or *KdeE* for short), suggesting a space consecrated both to pleasure and to disillusion, and this alternative nomenclature points back to the autobiographical interpretation of *Das Grünes Kind*, which in turn is borne out by the few photographs that seemingly document the development of the

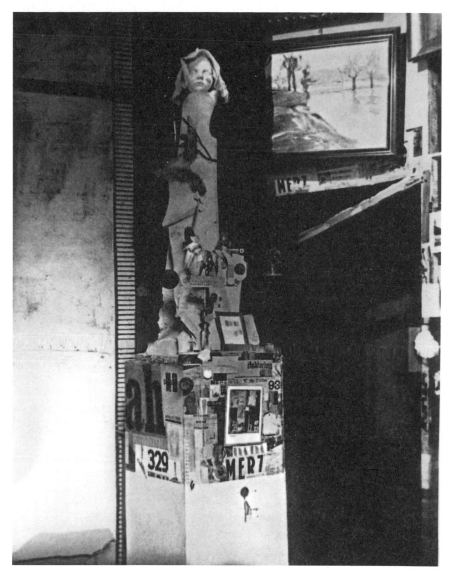

fig. 5 Kurt Schwitters, *Untitled (Merz column)*, *c*.1923

Merzbau/KdeE. The first of these dates from around 1920 and shows a work known as *The First Day Merz Column* standing in the corner of Schwitters' studio – the construction is topped with a portrait bust of his wife Helma, which we know to have been entitled *Lieden (Suffering)*. A second picture from 1923 shows a subsequent variation on *The First Day Merz Column*: here Helma's portrait bust has been replaced by the plaster death mask of the couple's son and elements from the column have begun to *merz*, or merge, with the surrounding walls. In a later image from 1925, the column of 1923 appears again, here apparently stripped of many of its collage elements and framed by the vertically radiating forms of the surrounding architecture of the *Merzbau*; the death mask itself is softly illuminated from one side producing the illusion of benign but eerie animation.

Schwitters
see above fig. 5

Schwitters
see overleaf fig. 6

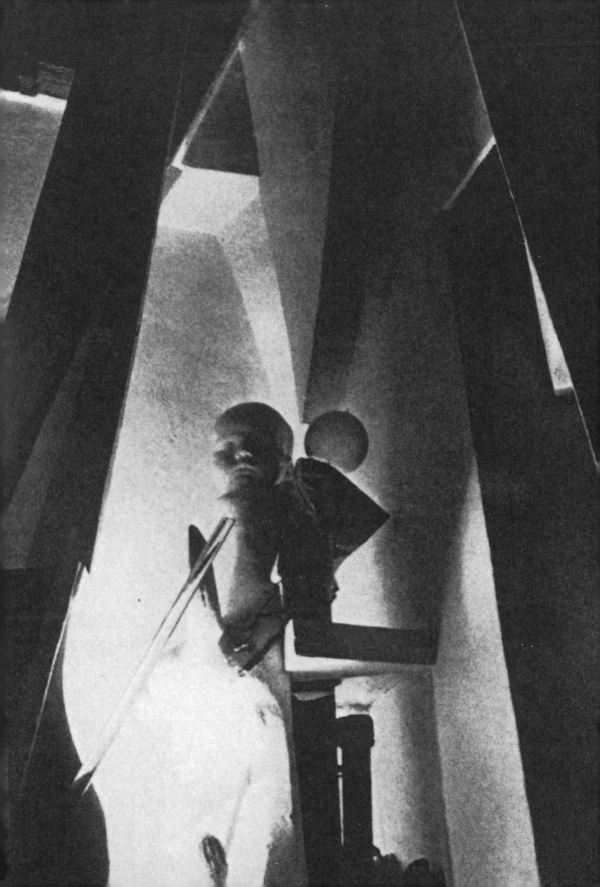

Despite the prominence of the death mask in these photographs, Schwitters' descriptions of the *Merzbau* include not one reference to it. According to anecdote[8] the artist saw the death mask as the embodiment of his son's benevolent presence, initially placing it on a shelf in his studio and later incorporating it into his work as a sculptural element. If we run the dates of Gerd's birth and death (1917) in a sequence with the birth of Merz (1919) and the first germinations of the *Merzbau* (1920), a clear trajectory of meaning begins to emerge for Schwitters' *Lebenswerk*. It begins as a monument to the dead infant and morphs into a kind of multi-faceted mausoleum: a provisional cemetery for the living (Schwitters himself, his many friends, his second surviving son Ernst, and his guinea pigs, whose presence accounted for the *Merzbau's* pungent odour – its most memorable aspect for many visitors) and the dead (Goethe, Luther, and the hideously mutilated victim of the sex murderer). Eventually it grows into a cathedral in which these disparate elements coexisted; associated through the idea of 'erotic misery' that was inextricably bound to the secret of the dead child; a subject which, despite its veiled appearance in many of Schwitters' works, he made such scant reference to during his life that the details of Gerd's birth and death have only recently been confirmed.

Interring the remains of relatives within the walls of the family home in order to ward off evil has been a common practice in many cultures, while death itself has sometimes been used as an architectural element as in the church of Santa Maria de la Concepción in Rome where there is a chapel decorated with the bones of Capuchin monks buried there.[9] Whatever Schwitters' conscious references, the dominant themes of the *KdeE* – like Duchamp's *Étant donnés* – played around the relationship between eroticism and mortality, a preoccupation as much provoked by personal experience as it was affected by external events. *The Sex Crime Cavern* in the *Merzbau* is likely to have been inspired by the lurid antics of a serial killer operative in Hanover in the early 1920s, while the foreboding syphilitic child in the *Grotto of Love* may originate from the film *Let There Be Light*: a box office sensation of 1918 that dealt with the destructive nature of syphilis and, like many films produced around this time, used hygiene and sexual enlightenment as the means to bewitch censors into overlooking frequent excursions into pornography. In view of what seems to be a very specific reference, if not to the actual film then to a well-founded contemporary paranoia, it is worth briefly considering what other films Schwitters, who we know to have been an enthusiastic cinema-goer, might have seen around this time.

In the immediate aftermath of the First World War, the Council of People's Representatives abolished censorship in the mistaken belief that this would effect the transformation of the screen into a political platform. It had the opposite effect, instead spawning a deluge of products with titles like *Hyenas of Lust, Women Engulfed by the Abyss, Vow of Chastity* and no less than three sequels to *Let There Be Light*. In his study of German film of this period, Siegfried Kracauer speaks of the aura of sadness that pervaded these films, and suggests that the retreat into the pleasures of the flesh that they provided fulfilled a deep need on the part of the German people, who had been thrown into a state of psychological paralysis in view of the freedom offered to them under the newly constituted state:

Millions of Germans, in particular middle class Germans, seem
to have shut themselves off from a world determined by allied
pressure, violent internal struggles and inflation. They acted as
if under the influence of a terrific shock which upset relations
between their outer and inner existence. On the surface they lived
on as before; psychologically they withdrew into themselves ...
retreated into a shell.[10]

There are echoes here of Jahns' description of the world whirling away from
him as he sits in the centre of the *Merzbau*. Although an established member
of the avant-garde, Schwitters emanated from, and lived as part of, the middle
class. And just as his clandestine world was permeated by the pathologies of
contemporary society – disease, disfunction and the abuse of power – so the
cinema of the interwar years, which according to Kracauer provides 'a unique
secret history revealing ... almost inaccessible layers of the German mind',[11] is
a phantasmagorical claustrophobic place replete with tyrants, child murderers,
sex offenders, insane scientists and powerless victims. Narrative aside, the
most obvious affinity between the *Merzbau* and the films of the time is in the
formal qualities of the sets that make liberal use of the fractured shapes of
Expressionist architecture. And this world of exaggerated artificiality, which
relies on many of the illusionistic tricks of light and vertiginous perspectival
distortion used by Schwitters in the *Merzbau*, could in both cases be interpreted
as the spatial expression of the tortured soul. One contemporary reviewer of
the Expressionist classic of 1920, Robert Wiene's *The Cabinet of Dr Caligari*,
characterised the film with the phrase, 'real people in an unreal world'.[12] It is a
thought that may well have occurred to visitors to the *Merzbau* who, navigating
their way through its labyrinthine passages, might have had the sensation that

Wiene
see below fig. 7

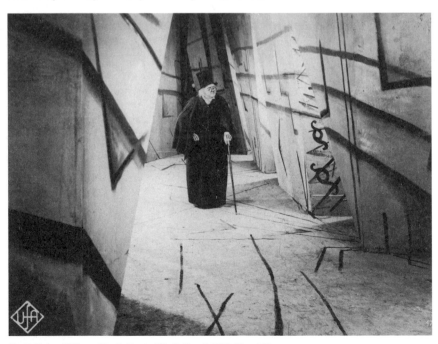

fig. 7 Robert Wiene, *The Cabinet of Dr Caligari*, 1920 (film still)

fig. 8 Marcel Duchamp, *Étant donnés: 1 la chute d'eau, 2 le gaz d'eclairage*
(Given: 1 The Waterfall, 2 The Illuminating Gas), 1946–66

they were clambering around a film or stage set. Like *Étant donnés*, the
Merzbau engaged the viewer in a total experience, taking the form of what
would now be described as installation, long before the concept was articulated.

This is a good point at which to return to Duchamp who was inspired by
cinema more wittingly than Schwitters. The French artist was fascinated by the
retinal qualities of the medium, in particular its 'potential for the expression of
movement,'[13] a fact made clear by his first celebrated work *Nude Descending
a Staircase* (1912), which was painted in response to Étienne-Jules Marey's
experiments with chronophotography.[14] While Schwitters' *Merzbau*
incorporates some of the narrative and formal attributes of cinema, *Étant
donnés* represents the apotheosis of Duchamp's interest in optical games by
deploying a barrage of tricks borrowed from cinema and pre-cinema: the
framing device of the museum which, like a movie theatre, contains the work
in its entirety; the large door set in the wall in the empty room, which appears

Duchamp
see above fig. 8

to lead somewhere but strangely does not open; the peep holes, which like a stereoscopic viewer control the angle of observation completely; and, finally, the astonishingly real illusionistic landscape that they reveal with its distant trickling waterfall, shining light and shockingly lifelike headless female figure – apparently the victim of some unspecified sex crime. *Étant donnés* plays a controlled game of hide and seek with the viewers' visual expectations, turning them into voyeurs, 'for it is voyeurs who make pictures',[15] while the *Merzbau's* trick of concealment was more literal: all was revealed, but only once permission to enter had been granted.

Duchamp see opposite fig. 9

But the real difference between the two works lies in their intentionality. *Étant donnés* was designed for posterity because in Duchamp's view 'the contemporary viewer is of no value whatever.'[16] The work achieves its impact through a series of elaborate mediations and alienating devices, the most significant being the mediation of death between work and viewer. Duchamp planted carefully controlled clues and insinuations to the work's meaning and these continue to provoke reams of scholastic speculation, the effect of which have been to ensure the inviolability of Duchamp's position in modern and contemporary art. He also bequeathed for posterity a meticulously compiled instruction manual explaining how *Étant donnés* could be taken apart and put together – like an engine or prefabricated house – should the need arise to transport it from one location to another. Schwitters, by contrast, considered the *Merzbau's* immovability to be one of its greatest virtues; he thought – mistakenly – that this would ensure its safety.

Towards the end of her biography of her friend and collaborator Schwitters, Kate Steinitz ruminates over the fate of the *Merzbau*:

> If the column had not been entirely destroyed by a bomb, if it
> had only been buried, it might have been excavated after a few
> centuries. Then one would have found, as if in a time capsule, deep
> inside the column, the hidden life of Schwitters' soul, his struggle
> with all the problems of life, art, language and literature and
> human and unhuman relations.[17]

Did Steinitz really believe that future historians would be able to draw definitive conclusions from this mysterious work whose meaning was concealed or inadmissible even to its creator? Whether she did or not, her comment is revealing in that it posits the *Merzbau* not as the formal experiment, 'an abstract cubist sculpture that people can walk into ... a composition without boundaries',[18] but as an extension of Schwitters the person. Considering Schwitters' repeated declaration, 'I am merz', Steinitz's comment, made some 20 years after his death, should be taken as more than sentimental rumination.

Steinitz herself was Jewish and she and her family had fled Hanover for the USA in early 1936. Until that point, Schwitters had turned a blind eye to the inexorable rise of National Socialism, retreating into the *Merzbau* as prestigious design commissions and invitations to exhibit and lecture evaporated. But the departure of the Steinitz family left him deeply unsettled and isolated, and in early 1937 – just a few months before Hitler posed for a photograph in front of a merzcollage on the occasion of the opening of the

fig. 9 Marcel Duchamp, *Étant donnés: 1 la chute d'eau, 2 le gaz d'eclairage (Given: 1 The Waterfall, 2 The Illuminating Gas)*, 1946–66

cat. 5 Kurt Schwitters, *Cottage on Hjertøya (after the extension with Ernst Schwitters)*, *c.*1935

Degenerate Art exhibition in Munich – Schwitters fled to Norway. Before leaving, he and his son Ernst photographed the *Merzbau*. Schwitters never returned to Hanover; the pictures were his only reminder of his *Lebenswerk*, and today they provide the most comprehensive record of it.

During his years in exile Schwitters rebuilt the *Merzbau* three times. First, behind trees at the end of a sloping suburban garden in Oslo, hidden from the view of the local police who nevertheless questioned the artist after suspicious neighbours reported that the *Haus am Bakken (House on a Slope)* concealed an enemy transmitter. Then, in a hut on the island of Hjertøya in the north of the country. When Nazi troops invaded Norway in 1940, Schwitters fled to the UK where he was initially interned as an enemy alien and eventually released in the autumn of 1941. He settled first in London and then in the Lake District where, in 1947, assisted with a grant from the Museum of Modern Art in New York, he began work on a fourth and final version of the *Merzbau* – the *Merzbarn* – situated inside a former gunpowder store on a farm near the village of Elterwater. By this time Schwitters' compulsive need to enclose himself in a sculptural shell had grown to a full-blown obsession, and he continued to work through one of the coldest winters on record, falling ill repeatedly until he was unable to continue. On 8 January 1948, he died from complications arising from pneumonia. The Museum of Modern Art's suggestion that his body be interred within the walls of the *Merzbarn* was rejected, as was Schwitters' own wish to have one of his Merz constructions placed on his grave in lieu of a tombstone. Instead, a small merzsculpture was buried with him.

The material objects that Schwitters created during his life have not worn well. The colours of his paper merzcollages and painted sculptures have faded, the Hanover *Merzbau* was completely destroyed by bombs, the *Haus am Bakken* was burnt to the ground by children playing with matches in what they called the 'ghost house', the *Merzbau* in Hjertøya is rotting and inaccessible,

Schwitters
pp. 100–101
cats 33–34

Schwitters
p. 12, fig. 3

while the *Merzbarn* survives now as a fragment. Hugo Ball's conviction that Dada was 'game with shabby remains'[19] can be aptly applied to Schwitters' practice which continues to fascinate principally because the rules and meanings of his particular version of this 'game' are so unfixable and complex; as he said of the *Merzbau* specifically, 'it is hard to understand because of its ambiguities'.[20] During his time in Norway and the Lake District Schwitters was increasingly drawn to the beauty of the natural world, a place reassuringly governed by the predictable cycles of the seasons. His poem about the elements is anything but ambiguous; originally written in English it goes like this:

> When I am talking about the weather
> I know what I am talking about.[21]

Clare Carolin

1. For a full account of this period see N. Guterman, *World in Trance*, Hamish Hamilton, London, 1943; and M. Jay, E. Dimendberg and A. Kaes (eds), *The Weimar Republic Sourcebook*, University of California Press, Berkeley, 1994.
2. K. Schwitters, quoted in W. Schmalenbach, *Kurt Schwitters*, Thames & Hudson, London and New York, 1970, p. 52.
3. K. Schwitters, An Anna Blume, quoted in S. Thomerson, *Kurt Schwitters in England*, Gaberbocchus Press, London, 1958, p. 37.
4. K. Schwitters, 'Ich und Ziele' in 'Das literarische Werk', pp. 344–45, tran. John Elderfield, *Kurt Schwitters*, Thames & Hudson, London and New York, 1985, p. 161.
5. ibid., p. 423–24.
6. ibid., p. 423–24.
7. R. Jahns, quoted in E. Burns Gamard, *Kurt Schwitters' Merzbau: The Cathedral of Erotic Misery*, Princeton Architectural Press, New York, 2000, p. 102.
8. See E. Burns Gamard, p. 52–3.
9. See M. Ragon, *The Spaces of Death: A Study of Funerary Architecture, Decoration and Urbanism*, University of Virginia Press, Charlottesville, 1983; and D. Hollier, *Against Architecture: the Writings of Georges Bataille*, Cambridge, MIT Press, 1989.
10. S. Kracauer, *From Caligari to Hitler: A Psychological History of the German Film*, D. Dobson, London, 1947, p. 59.
11. ibid., p. 60.
12. Quoted in M. Budd (ed.), *The Cabinet of Doctor Caligari: texts, comments, histories*, Rutgers University Press, Piscataway, 1990.
13. M. Duchamp, quoted in P. Cabanne, *Dialogues with Marcel Duchamp*, Thames & Hudson, London and New York, 1971, p. 40.
14. For a fuller account see J. A. Ramirez, *Love and Death, Even*, Reaktion Books, London, 1998.
15. M. Duchamp, quoted in P. Cabanne, op. cit., p. 143.
16. M. Duchamp, quoted in P. Cabanne, op. cit., p. 143.
17. K. Steinitz, *Kurt Schwitters: A Portrait from Life*, University of California Press, Berkeley, 1968, p. 398.
18. K. Schwitters in *Abstraction Creation: art non-figuratif*, Association Abstraction Creation (Paris), # 3, Paris, 1933.
19. H. Ball reciting *Karawane*, Cabaret Voltaire, Zurich, 1916. Quoted by H. Foster in 'Dada Mime', *October 105*, Summer 2003, p. 169.
20. K. Schwitters, quoted in E. Burns Gamard, op. cit., p. 89.
21. K. Schwitters, quoted in S. Thomerson, op. cit., p. 47.

cat. 6 Oskar Voll, *Notebook No. 9 (inventory 360) folio 5 recto*, 1910–20

SECRECY

> We are trying to penetrate a three-dimensional symbolic labyrinth
> set within a virtual space and a 'sacred' time which, defying the
> accustomed conditions of understanding, are located on the *other*
> side of the mirror.
>
> René Alleau, *Aspects de l'alchimie traditionnelle*, 1953

Despite the efforts of our contemporary media, which ply us with
unprecedented reams of information, and despite the lulling reassurances we
are repeatedly given as to our sovereignty as the supreme species, the universe
we inhabit remains, quite fundamentally, a mysterious and ill-known place. As
humans, we aspire to knowledge about our own kind and to expertise in judging
nature's design: we like to think that science will one day have solved each last
riddle of earthly existence. But whenever physicists (for example) lay bare the
most intimate patterning of organic forms, they seem unable to communicate
their insights to the masses in a clear and accessible manner. In former times,
the practitioners of alchemy decided that it was altogether too risky to expose
nature's secrets to all and sundry: hence alchemical treatises are crammed with
arcane symbols and coded allusions that allow occult lore to pass from adept to
initiate while looking like gibberish to the profane. Many religious movements
have likewise clothed their fundamental ideas in symbolic garb, safeguarding
their credo from vulgar hands. Camouflage is a defensive strategy well known
to military commanders and to certain insects and animals. Messages in code,
and messages in a foreign language, tend to resemble sacred texts in their
intractable opaqueness.

Secrecy has always been linked to power, for to deprive others of knowledge
is automatically to assert one's superiority over them. A secret unshared can
be a weapon of mystification and ultimately of violence, for even if one denies
access to knowledge in a mischievous or teasing manner, it is still the case that
the person kept in the dark will feel frustrated, cast out from any circle of
complicity. We exploit privileged information to get ahead of others, to arrive
first in the queue, to pre-empt their attacks, to starve them of initiative and thus
make them subservient. Secrecy and dissembling are prominent in all spheres
of life, from the playground to the parliament, from the quiz-show to the
interrogation chamber, from the boxing-ring to the battlefield.

Our best friend at school was always the one to whom we told our ultimate
secrets. To confide in another while demanding they tell no one else is to put
one's faith in an unusual loyalty. Deep friendships are nurtured on such sharing,
or collapse spectacularly through eventual betrayal. Secrets may take many
forms, ranging in importance from trivial gossip to data of life-or-death
significance. Many a government has made a cult of secrecy, invoking it as
ground for concealing sensitive intelligence in times of crisis, and implementing
it ruthlessly whenever telling the truth would undermine its own authority. A
person's success in handling secrets rests upon his or her aptitude for gauging
the instinctive responses of others: sometimes it is better to cover up an
innocuous gaffe rather than risk the taunts of a false friend. As Sigmund Freud
realised, we repress the memory of our guilty acts (as well as the memory of

innocent acts that somehow get contaminated by feelings of guilt), and such vibrant secrets, buried deep within the psyche, tend to fester over time and to lead to conflictual spasms within the individual that only the psychoanalytic conversation can relieve. As Catholic doctrine likewise asserts, the guilty truth needs to be spoken if inner harmony is to be restored: the secret kept secret, kept only to oneself, is always something of a time bomb. Yet without some kind of secret life, one would be a nobody.

In the long term, extreme secrecy may be of doubtful benefit. For if I hold my cards too close to my chest, I may end up missing the one crucial moment when I can play them to advantage. If I possess some secret shared with no other person, the consequence may be that I experience continual panic, fearing that others are generally wiser and shrewder than myself and, in so far as they generally 'know better', need only one peep at my secret to gain immediate hold over me. Secretiveness promotes paranoia: the more I fear losing my grip on my secret, the more I lose track of reality, the more I need to shore up my faltering self-esteem through absurd strategies of self-assertion. Patients in mental hospitals often hide away small objects, as if to nominate them as symbolic guardians, which in turn need to be fiercely guarded. Similar mechanisms of security can be identified in other contexts, as with the child's hidey-hole behind the bed or the spy's cache of pistols and passports under the floorboard; or again, at the wider level, the dictator's hoard of illicit weapons in a closely guarded zone unmarked on any map. The nightmare of George Orwell's *1984* lies in its vision of a society where individual secrets have been outlawed, while Big Brother remains ubiquitous and unknowable. The novel's protagonist Winston Smith's penning of a frenzied diary in an alcove out of reach of the security cameras represents a last-ditch attempt to sustain the secret of personal difference against the indifferent levelling of social conformism.

Western culture has long been fascinated by secrets, by the fanaticism of their cultivation and by the thought of the explosions that might ensue, were they ever laid bare. We attribute considerable value to the phenomenon of secrecy, in so far as an object withdrawn from normal circulation, or a fact not spelled out for all to share, are potential loci of intense meaning, pockets of density that belie the evenness, the blandness, of the run of experience. To stumble upon a secret, as when we accidentally open someone else's private mail, is to be propelled into a state of moral agitation. An unsuspected revelation can throw up sensations of guilt, incredulity, dismay or horror. The experience is ambivalent: it energises us, impels us to act, yet tends to leave us panting with conflicting thoughts. Perplexed, we are nevertheless on our toes.

In that their task is to articulate fresh meanings in regard to our cultural and natural surroundings, it falls to the artists in our society to exploit all possible modes of communication: speaking, writing, drawing, painting, sculpting, taking photographs and the rest. These range between the allegedly univocal mode of linguistic utterance to the more ambivalent or multivocal modes of visual expression (e.g. painting) and non-verbal performance (e.g. ballet). The fact that the disposition to artmaking sometimes coincides with the disposition to secrecy should give us pause for thought, given that our culture has traditionally ordained that art should adhere to truth, and be committed to procedures of sincere avowal rather than to lying or dissembling. In practice, the very

pluralism of the choices that confront the creative subject may trigger the impulse to self-concern and secrecy. What medium to choose? Pencil, pen or brush? Monochrome or colour? Haste or slowness? Spontaneity or design? Am I making something whose signifiance I can foresee and control? Could I be structuring something that 'feels right', yet whose shapes suggest something quite unforeseen? Exactly whom am I addressing? The expressive choices I make could implicate me in an unintended admission that robs me of my sovereignty and my reputation. Creativity connotes vulnerability. Far better, then, to proceed warily, taking detours, covering my tracks, relying on stealth rather than innocence: *ars est celare artem* ('true art is to conceal art'), and a certain deviousness may be endemic to the artistic performance.

Darger
pp. 57–63
cats 11–16

The 'outsider' artist Henry Darger produced a life's work in the form of hundreds of large coloured pictures that illustrate his monstrously long fantasy novel, *In the Realms of the Unreal*. Nobody had any idea that he was a creator, his clandestine *magnum opus* coming to light only upon his death, stacked within the cramped bedsitter that had been both his home and studio. Lacking access to the author, we can nevertheless divine what were Darger's private preoccupations, for his writing is clear and purposeful (even if it is obsessive and monotonous), and his scenes of warfare and mayhem are not exactly ambiguous. Here is the classic case of a species of confession being handed down to posterity, whether intentionally or not. And posterity's delectation seems to be inseparable from the sensation of peeping at something that perhaps should have been kept under wraps.

Just as Samuel Pepys kept a diary in code, so certain artists have invested in strategies of concealment, producing art that is private, inscrutable and baffling. Through history, hermeticism has served to deter the non-initiate and to foster solidarity among a privileged élite. The Paris Symbolists of the 1880s, for instance, drew strength from the example of their master, Stéphane Mallarmé, whose idiosyncratic poetry cloaked its meaning in a dazzling parade of rare words and impenetrable sonorities. Such a conscientiously occulted idiom meant that each poem presented itself as a riddle to be solved. However, some critics fell into the trap of supposing that, given sufficient time, patience and ingenuity, they could tease out a single meaning (usually a banal one), and thereby missed out on that dimension of fertile polyvalence that was Mallarmé's true and admirable goal, a dimension of higher meaning that flat prose could never approach. As all lovers know, secrecy increases passion; and although it can be vexing to those not in the know, obscure expression in art often enhances an original proposition, converting it to a higher power.

Some artistic expressions are so coloured by the feelings of the creative subject that they resemble blatant exposures of the sensibility. We may sometimes feel inclined to ask artists such as Egon Schiele or Francis Bacon to tone down their revelations, given that another person's self-exposure can seem to compromise our own defences. At the other extreme are the fastidiously encoded statements of those who feel compelled to guard against too much subjectivity. The art of Josef Albers or Ellsworth Kelly, for instance, somehow incontrovertible in its clear-cut formality, may attract our admiration because its aesthetic autonomy resembles the perfection of the well-kept secret, like impeccable camouflage. In the field of mental dysfunction, the phenomenon of

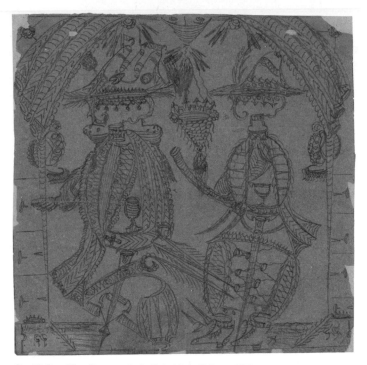

fig. 10 Jean Mar, *Promenade du Roi et de la Reine*, c.1908

autism represents a retreat from ordinary communication so extreme as to render the individual's self-expression impervious to the understanding of others; the existential withdrawal of the deaf-mute James Castle or of the introvert schizophrenic Jean Mar led to their opting for the most arcane ways of handling imagery and words. Extreme clinical autism makes of the self a citadel inaccessible to others; therapies that encourage art-making are nowadays seen as a way to open the barred gate.

Mar
see above fig.10

The artist Oskar Voll was a long-term patient in a mental hospital in Germany in the early years of the twentieth century. Diagnosed as suffering from schizophrenia, paranoia and dementia with periodic states of agitation, he was undoubtedly treated as an incurable case. The last thing one might have expected of him was an aptitude for art. When it came to light that he had produced a number of sketchbooks and drawings, these were forwarded to Dr Hans Prinzhorn in Heidelberg, to be subsumed within his pioneering collection of psychotic art. Voll's case notes have since been lost, so that next to nothing is now known about his early life. A century later, we address his curious drawings and try to tease out their secrets.

Voll
pp. 111–13
cats 40–42

Voll's repetitive, obsessional images in dark graphite include scenes of cavalry and artillery officers in resplendent uniforms, suggesting that Voll had seen military service. Sentinels and horsemen are depicted in dark silhouette within a virtual space where moonlight casts no shadow. These figures seem frozen, as if caught in states of bemusement or trance. The mystery is compounded by the insertion of accessories: an unexplained dumb-bell, a bottle, a globe, a closed box, a giant black beetle, an indecipherable letter. Where

several figures occupy the same space, they frequently peer in quite different directions, suggesting that each is intent on his own private preoccupations. The atmosphere is both disquieting and beguiling, a surreal stillness that seems of a piece with the brooding scenarios of the artist Giorgio de Chirico, the proponent of *Pittura Metafisica* (Metaphysical Painting) and designer of mesmerising enigmas. Remembering Freud's concept of the Uncanny (*das Unheimliche*), with its co-mingling of the alien and the familiar, we sense we are on the brink of being inducted into a secret, and yet we seem incapable of pinning down the context within which the incongruous signs and symbols might make sense. One drawing shows an officer surprised by a shooting star at the window. On the table before him lies a sheet of paper, on which we can read the words 'Philadschier Palsatiner Rinana Parmia Piuma'. The artist offers no help in interpreting this text. We may elect to dismiss it as just a bit of stammering nonsense. And yet for Voll to have deliberately contrived this riddle cannot be a totally meaningless act. Here is a secret to be acknowledged, if not penetrated.

Voll
p. 42, cat. 6

We have, as it were, stumbled upon an *art of enigma* whose secretiveness frustrates normal interpretation. We find ourselves peering as through a glass darkly, absorbed in the trappings of secrecy, its elaborate indirection, the flourish of the vanishing trick. The best practitioners of such art tend to exhibit a serene and consistent deviance. Marcel Duchamp was a master of the sleight-of-hand whereby meaning is simultaneously offered and withdrawn: revelation as re-veiling. The viewing holes drilled high in the wooden door of his last piece, the installation known as *Étant donnés* (1946–66), are a tongue-in-cheek allusion to the awkwardness of our posture as viewers. As with such earlier mysteries as his work *The Large Glass* (1915–23), Duchamp insists on our attending scrupulously to what we take to be profound disclosures,

Duchamp
p. 37, fig. 8
p. 39, fig. 9

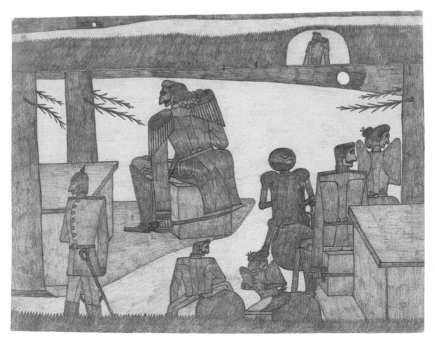

fig. 11 Oskar Voll, *Untitled drawing* (Inv. 282), date unknown

yet always keeps us waiting before a locked door. Like the alchemist or the spymaster, he addresses an élite circle of initiates, while frustrating the latecomers stuck outside.

Kurt Schwitters is another maestro of secrecy and studied obliquity. As a Dadaist, he invested wholeheartedly in the principle of unreasoned speechmaking, producing illogical narratives and sound-poems based on vowels and syllables shorn of significance. The thousands of collages that were Schwitters' main output over some four decades are testimony to a drive to seek meaning through the painstaking sabotage of meaning. Built up from newspaper cuttings or scraps scavenged from the wastebin, the typical collage is a demonstration of nonsensical disjunction; and yet its deftly pasted layers hint at an underlying cohesion, perhaps having to do with the implicit constancy and earnestness of its author. The three-dimensional *Merzbau* that Schwitters assembled in the back of his Hanover house, and which was destroyed by bombs in 1943, was a remarkable work of synthesis, a *Gesamtkunstwerk* saturated in secrecy and comprehensible (so Schwitters himself reckoned) to a mere handful of associates. In truth, the destruction of this legendary work carried it onto a new plane of meaning, for it exists now as a labyrinthine myth, the compendium of all that has been surmised about it: it can be seen as the ultimate work of enigma, a secret we all can share, not least because there is no authority to deny our right to delve into its protean connotations.

Schwitters pp. 25–28 cats 2–4 pp. 97–99 cats 30–32

Secrets that are never uncovered tend, by definition, to remain absolute and irreducible. If properly tended, they escape notice altogether, and it is no doubt the case – though we necessarily rely on supposition here – that countless secrets have died with their keeper. Yet once we have recognised a situation, an object, a text or an artwork as harbouring a secret, we tend to be intrigued and even to cherish our bemusement as a special kind of pleasure. As with Medusa's gaze, we feel drawn to confront a challenge. We half-know that riddles without clues could drive us mad. We sense that secrecy is addictive and ultimately dangerous. Risk likewise is hard to resist. There may be no earthly chance of deciphering the code or piercing the disguise, and yet we press forward, as if something as precious as life itself were secreted in the tell-tale detail, the whispered confidence. 'Philadschier Palsatiner Rinana Parmia Piuma' – there is always *something else* beckoning on the other side of the mirror.

Roger Cardinal

ARTISTS

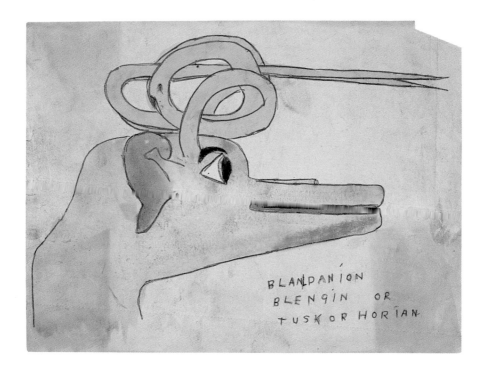

SOPHIE CALLE

Born 1953, Paris, France
Lives and works in Paris, France and New York, USA

One of Sophie Calle's most personal works is *The Birthday Ceremony* (1998).
Although dated 1998, that is, the year of its completion, the work has its origins
from 1980 to 1993 when Calle invented and sustained a series of rituals around
her birthday. Feeling insecure and wishing to remind herself of the love of her
friends, each year, on her birthday, Calle threw a dinner party to which she
invited a number of guests corresponding to her age. Their birthday gifts were
displayed in a cabinet, and on each successive birthday, the gifts from the
previous year were archived and replaced with new gifts. During stressful
periods in her life, Calle would unpack the birthday archive to remind herself
of her friends' support. Following her fortieth birthday in 1993, she realised
that she had been cured of her insecurity and so discontinued the ritual. The
work itself consists of a series of cabinets containing birthday gifts from each
year accompanied by descriptions of them written by Calle.

Like much of Calle's work, *The Birthday Ceremony* takes a vulnerable aspect
of her private life and places it on display. Instead of the abstracted internalised
expressions of many artists, Calle acts instead as a reporter or investigator –
into her own life or that of others – teasing out intimate details and exhibiting
them naked to the public eye. An early work, *The Detective* (1981), involved
Calle instructing her mother to hire a private detective to follow her daughter
in secret and document her activities; in Calle's words, it was an attempt
'to provide photographic evidence of my own existence'. In *Autobiographies*
(1988–92), she turned her voyeurism towards herself, closely observing and
meticulously documenting the development and eventual break up of a real
life relationship.

Photography, invariably part of Calle's formal language, is an ideal
medium for one interested in investigating personal details and, despite the
uncomfortably personal content of her work, it tends to have a cool, seemingly
objective presentation. In the series *The Hotel* (1981), photographs of what
she finds while rummaging through guests' possessions in the guise of a
chambermaid are accompanied by a methodical written record. For example,
in *Room 28*, she notes:

> Wednesday 18, 9 am. The two beds have been slept in. There is
> some progress on the crossword grid started yesterday. The pyjama
> bottom is still in the same place. I lift the suitcases: three of them
> seem to be full. I open them. In the first one I find a toilet kit, in the
> second a set of identical Brooks Brothers shirts with blue and white
> stripes. In the third one, a book *Artists in Crime* by Marsh, a Minox
> camera, a denture (lower jaw), a $7'' \times 9\frac{1}{2}''$ photograph of a sailing
> boat on the sea [...] I hear some noise, hastily close a suitcase and
> make the bed.

Sherman Sam

R O O M 2 8

Monday February 16, 1981, 9:30a.m. I go into room 28. Only one bed has been slept in. I find an impressive pile of luggage on the right along the wall. Four Vuitton suitcases stacked on top of each other, three travelling bags, a row of shoes: eight pairs for the woman (size 38) and five pairs for the man (size 42). I open the wardrobes. On the right, some men's clothes including three more pairs of shoes in felt covers, a hat, two pairs of white underpants and [illegible]. All of them of a fine quality. I imagine some older well-off people. In the [illegible], a pink flannelette nightgown. I put on some of the Chanel No.5 perfume, hastily open one of their suitcases. I catch a glimpse of The Economist magazine, some bananas in a plastic bag. Once the room is made up, I leave.

Tuesday 17, 9:10a.m. The twin beds have been slept in. In the wastebasket, the banana peels, a bottle of water and a pair of hardly worn black flat heels

(they fit me, I take them). On the chair, a thick white cotton pajama bottom. To the left, some mints, a crossword grid on a bedside table and some pink slippers within reach. On the right bedside table, an alarm clock, a flashlight, a roll of scotch tape, three pairs of glasses, a book Games with Love and Death by Arthur Schnitzler. In the chest upper drawer, I find two handbags, some pearl necklaces in a plastic bag and ten small identical boxes full of white pills wrapped in a Fitzgerald shoe cover. The two lower drawers contain some women's clothes, silk blouses, pastel color scarves.

Wednesday 18, 9a.m. The two beds have been slept in. [illegible] in progress on the crossword grid started yesterday. The pajama bottom is still in the same place. I lift the suitcases: three of them seem to be full. I open them. In the first one I find a toilet kit, in the second a set of identical Brooks

Brothers shirts with blue and white stripes. In the third one, a book Artists in Crime by Marsh, a Minox camera, a denture (lower jaw), a 7" x 9½" photograph of a sailing boat on the sea, a reservation at the Milano Carlton for February 19, a portrait of the Pope, an envelope addressed to Mrs. H., Baltimore…with the following notations on the back: Jean-Paul Belmondo, rue de la Paix, Paris 5e (the street number is not mentioned, the arrondissement number is wrong, the post-office cancellation has been written over with a ball-point), a series of index cards with columns of numbers (stock exchange quotations?)…. I hear some noise, hastily close the suitcase and make the bed.

Thursday 19, [illegible] left nothing behind. I take a last photograph of the unmade beds. The memory [illegible] obscene image of the pajama bottom, stupidly lying on the chair.

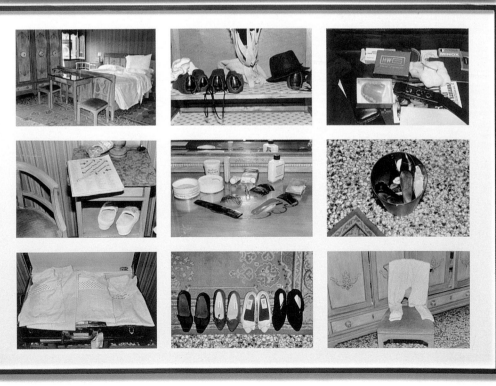

cat. 8 *The Hotel, Room 28*, 1981

ROOM 29

Saturday February 28, 1981. 10:15 a.m. I go into room 29. The twin beds have been slept in. On the table, some leftovers in a plate, two glasses, a bottle of water, some Diana cigarette butts in the ashtray. It seems to me at first that the room has been sweated. Then I notice a pair of tennis shoes sticking out from under the wardrobe and a white cap with a Sergio label hanging on the coat-rack. In the bathroom, two toothbrushes: a new one, red, still in its package, the other one yellow, in a blue plastic case, an Italian toothpaste, a big white sponge. Nothing else. I open the wardrobe. Inside I find a large closed suitcase, a handbag, a small suitcase, a plastic bag containing two pairs of slippers (size 36 and 41), two yellow sweaters and, lying on the suitcase, a small hardcover notebook with the inscription: "Ricordo de matrimonio" (Wedding souvenir). I leaf through it, very moved: C.S. born in Pisa in 1958 and F.C. born in Pisa in 1957 were married on February 26, 1981 at eleven o'clock in Casciavolla. My first couple on a honeymoon. In the handbag I find some cigarettes and a white handkerchief, in the small suitcase some toilet articles. And in the bigger suitcase, a large white towel, a white sheet, a pair of white panties, a white embroidered slip, a pair of black socks. I clean the room, make the bed. Lifting the sheets, I find their two pajamas, a white one with small red and blue flowers, the other in blue flannelette, and a long black hair.

Sunday March 1. 9:30 a.m. They have gone. I clean up the room.

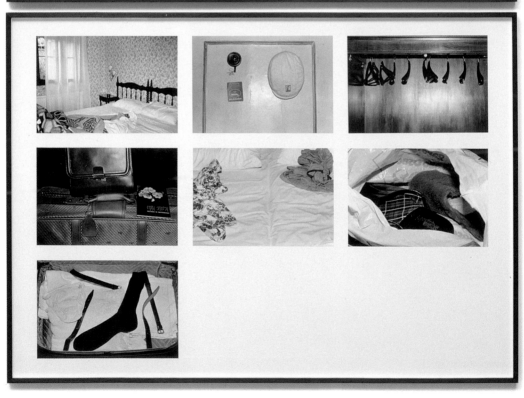

cat. 9 *The Hotel, Room 29,* 1981

ROOM 44

Tuesday February 17, 1981. 10:00a.m. I go into room 44. Just one unmade bed, on the left. On the luggage stand is a nylon traveling bag, locked with a padlock. In the bathroom, cosmetics, a bottle of J'ai osé eau de toilette, black stockings, and a pair of white panties which are drying. I think of the man who stayed in this room yesterday with the same sense of privacy, he who slept in the right-hand bed. Fleeting images of a missed encounter.

Wednesday 18. 10:20a.m. She wears green pajamas; they've been left on the pillow. On the table, some Kleenex and a book: Terapia 90. [...] bath. The room is still just as clean, empty. I spray myself with perfume, [...] the room, and leave.

Thursday 19. 1:00p.m. The "Do not disturb" sign is still hanging from the door handle when I leave work.

Friday 20. Saturday 21. Sunday 22. Monday 23. The same situation: impossible to go in.

Tuesday 24. 11:00a.m; This time the two beds are unmade. On the left-hand pillow, the green pajamas. The person on the right sleeps without a pillow; in its place there is a mauve nightshirt with pink flowers, carefully folded. The mirror between the two sconces on the wall which faces the bed has been taken down. I find it in the wardrobe and put it back in its place. On the floor is a vase with flowers. The room has come to life. On the bedside table to the left, a stethoscope, a sphygmomanometer. On the right, a rosary and a bottle of mineral water. The bathroom is packed: curlers, bath cap, sanitary towels, creams, lotions...perfume, Jolie Madame by Balmain. In the wardrobe I find an electric blanket, dresses – almost all of them evening dresses, some clothes in imitation-leopardskin, a bright red nylon wig, a Venetian mask ...

Wednesday 25. 11:15a.m. The mirror [...] the mirror is still hanging on the wall. The night clothes are in their respective places: the green pajamas on the left, the mauve nightshirt on the right. Today, I dig around. In one suitcase I find English crackers, bandages, syringes. In the other, more crackers. And in a black handbag, a diary with only two addresses in Rome in the address section, under R and S, and for February 20, the words: "Amaretti, spugne" (cookies, sponge cake).

Thursday 26 and Friday 27: "Do not disturb."

Saturday 28. 11:30a.m. I am short on time. I make the bed. Apparently nothing in the room has changed.

Sunday March 1. Noon. They have left. The only traces of their stay: Nescafé and crackers in the wastebasket. There is the smell of smoke. The future occupants' baggage has already been brought into the room.

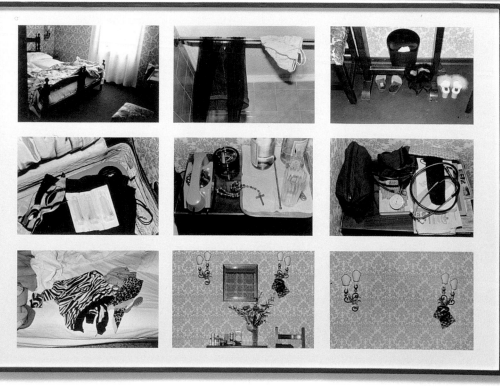

cat. 10 *The Hotel, Room 44*, 1981

ROBERTO CUOGHI

Born 1973, Modena, Italy
Lives and works in Milan, Italy

Like Father Like Son

Recently, friends have been congratulating Milanese artist Roberto Cuoghi
on how young he looks since he lost weight. Some say 30 years younger – which
seems alarming, given that he is only 32.

Then again, Cuoghi has just spent seven years disguised as his father. He let
his weight balloon to over 20 stone (127 kilos), grew a beard and dyed his hair
grey. Soon strangers were paying him the courtesies only the elderly receive,
and before long he began developing heart problems. Surprisingly, Cuoghi
makes the idea seem rather attractive.

It began for the simple reason that he wanted to disappear. 'I didn't want
certain people to recognize me', he says. 'I needed an alternative and I needed
to be credible. The image of my father was the closest alternative I could find.'
Cuoghi Sr was understandably confused, and Roberto says they did not really
talk about it. But he did help his son out with a few clothes.

Eventually, Roberto came to rather like his new identity. 'To be old and fat at
twenty-four can be convenient. You lose a lot of twenty-four-year-old paranoias,
and yet you are still too young to have the paranoias of a sixty-year-old.' But all
good things must end: eventually the state of his health made him anxious and
his cover was blown.

Now that Cuoghi is a young thing again, the art world is showing interest
in his old, fat self. This presents difficulties for Cuoghi, as he has not produced
much artwork to show for his experiences. Indeed, in 2002, when the curators
of *Manifesta 4* invited him to show something relating to his transformation,
he refused, delivering instead a film of the sun rising and setting – something he
says represents their misunderstanding of his intentions. One of the few pieces
relating to that time seems to be a profile self-portrait, his features nearly
obscured by plastic toys.

But Cuoghi denies that he never made any art about his experiences, saying
it is just a matter of what you see as art. 'In a certain sense, I did do it, and I am
doing it continuously. Now I want to stop doing it.'

Morgan Falconer

This article first appeared in *The Guardian*, Wednesday 29 June 2005

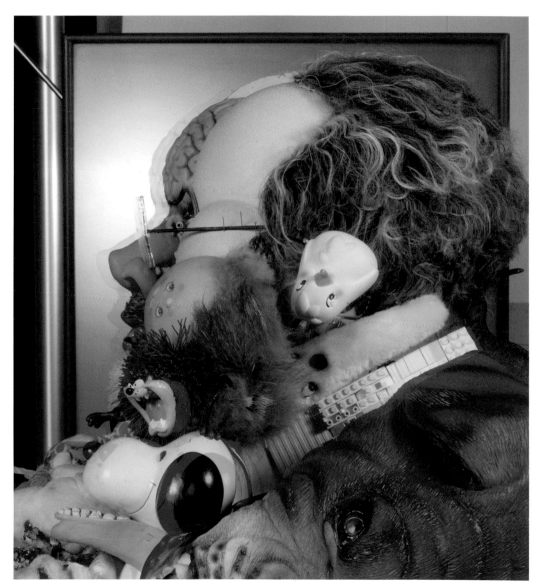

Fig 12 *Untitled (anaglyph version)*, 2005

HENRY DARGER

Born 1892, Chicago, USA
Died 1974, Chicago, USA

When Henry Darger died, at the age of 82, he left us another world. So exhaustively detailed was this war-torn civilisation that his illustrated novel, *In the Realms of the Unreal* (full title: *The Story of the Vivian Girls, in what is known as the Realms of the Unreal, of the Glandeco-Angelinnian War Storm, Caused by the Child Slave Rebellion*) runs to 15,000 pages. Darger began work on it when he was 19 and never stopped. It recounts the adventures of the Vivian Girls, seven sisters from the Roman Catholic land of Angelinnia, who, protected by magical, butterfly winged humanoid creatures, run about liberating child slaves from the evil, atheistic adult armies of Glandelinia. It is an epic tale in the style of a boys' (but in this case girls') own adventure, but filled with Hollywood blockbuster violence.

In reality, the story of Darger's life and work has come to epitomise that of the 'outsider'. The son of a tailor, at an early age Darger lost both parents. His mother died giving birth to a baby girl, who survived but was immediately given up for adoption, and for whom Darger searched hopelessly until the end of his life. By his own account, Darger's behaviour in school was strange and disruptive. At the age of 12 he was interred in an asylum for mentally feeble children, far from Chicago. Here, he and the other child inmates were forced to do heavy manual labour, an experience that clearly inspired the 'child slave rebellion' at the centre of his narrative.

Darger eventually escaped to Chicago, where he spent the rest of his life in various forms of menial labour. A devout Catholic, he attended mass several times a day, but his real adventures began when he crossed the threshold of his Chicago apartment where, every evening, the lands of Angelinnia and Glandelinia, on a distant planet from where Earth appears as a faraway moon, opened up to him. In a sense, the artist to whom he comes closest is the visionary poet William Blake who also merged image and text to create a world of conflict between good and evil.

Although Darger's imagery is replete with violence, it retains the charm and innocence of the cartoons and colouring books that inspired his compositions and provided the models for his characters. He would select a figure or motif from one of these sources, have it photographically enlarged and use this as the basis for his character studies. These were then incorporated into long horizontal compositions drawn on several sheets joined end to end to form a large hinged page. These long compositions – of which Darger made an estimated three or four hundred – are executed mainly in black pen and watercolour, and contain a visible wealth of obsessive craftsmanship and inventive technique including carbon transfer, tracing and collage. Entirely untrained, Darger considered himself untalented, yet he acquired the means which best suited his abilities and used these to tell his tales: extraordinary narratives known only to their creator until they were discovered by his landlord after his death.

Clare Carolin / Sherman Sam

cat. 11 *General Thomas Phelan Tamerlene, General Black Brooks,*
General Estrabrook Starring, date unknown

cat. 12 *Then true character was discovered, but when the Glandelinians*
were taking them from the camps in an auto, the machine got troublesome
and this enabled the little girls to so easily get away, date unknown

cat. 13 *Goodness didn't you kids ever see a flower this big*, date unknown

cat. 14 *At Jennie Richie, at shore of Aronburg Run River storm comes on anew*, date unknown

cat. 15 *Untitled (Landscape with cacti and rock formations)*, date unknown

cat. 16 *Untitled (Tree struck by lightning and butterfly winged blengin)*, date unknown

GEDEWON

Born 1939, Bagemdir, Ethiopia
Died 2000, Addis Ababa, Ethiopia

Gedewon called his works 'talismans of research and study', qualifying an old word with two others that also denote a university institute recently established in Addis Ababa and dedicated to Ethiopian history and art. Does this hybrid name indicate the inscription of a thousand-year-old art into modernity? Is it a way around the prohibition that today, as in ages past, attaches to forbidden knowledge? Is the artist admitting that he has produced only a simulacrum? All these are probably true, for Ethiopian talismanic art has always simultaneously copied models revealed to a few celebrated sages, such as King Solomon, and created images in response to particular situations.

Far from being an artist seeking his roots, Gedewon is one of the most skilled practitioners of poetry and rhetoric in the Orthodox Ethiopian Church. He was initiated secretly into talismanic art along with his religious studies. Talismanic art reaches back as far as the origins of Christianity in Ethiopia in the fourth century, and draws on the same Hellenic sources as Arab alchemy and the Jewish Kabbala. But while this art remained embryonic in the Mediterranean world, the Ethiopians developed it considerably, perhaps because they cleverly used it to cure patients whose ills they understood in terms of possession by a spirit. Gedewon's drawings, like those of his masters, are meant to be seen by spirits through the eyes of the human beings they inhabit.

According to Gedewon, talismans are a writing from a time before writing; they are at once and equally figure and writing. Their prototype is the Seal of the Father, which is typologically the equivalent of the Cross of the Son. This art is one of the secrets that were stolen from Heaven and revealed to humanity before the Flood. By a very long time it predates figurative painting, which began with the New Testament and was intended to serve didactic and mnemonic purposes. The talisman, on the other hand, is an image that operates on the visual level, as the names of God do on the auditory.

The talismans illustrated here were produced by Gedewon towards the end of his life, just as he was gaining wide recognition and exhibitions of his work were being presented internationally. As with his earlier work traditional patterns, such as those found in the *Net of Solomon* and similar talismanic books, are articulated across a large surface. Faces represent spirits while geometric patterns, are transformed into landscape elements. Thus the talisman is simultaneously a symbolic antediluvian construction, and a hallucinatory contemporary landscape inhabited by spirits

Gedewon worked by mounting his paper sheet on a thin board, supporting it on his knees and rotating it so that he always drew on the area closest to him. As a result his work has no spatial hierarchy; neither up nor down. In his 'talismans of research and study', Gedewon is both the healer and – because of his empathy – the patient. At the same time he is both the artist and the hallucinator in another's stead.

Jacques Mercier

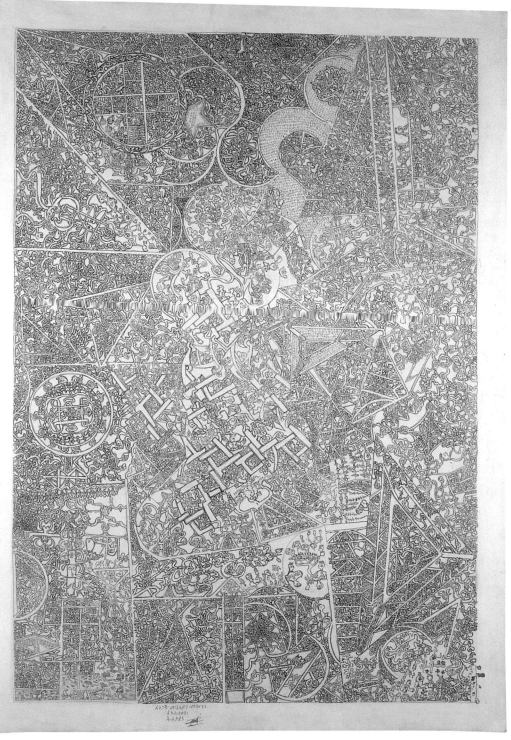

cat. 17 *Untitled #13*, 1992

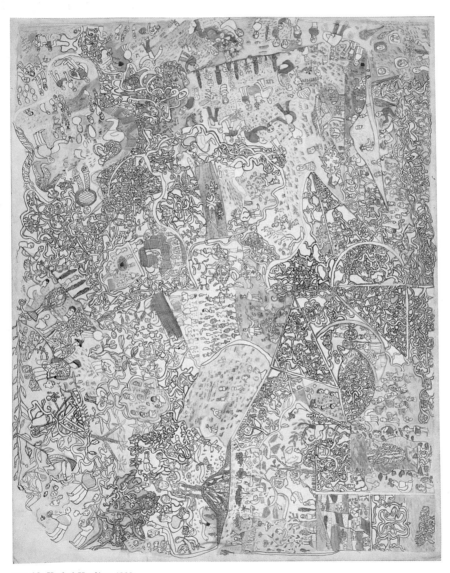

cat. 18 *Herbal Healing*, 1993

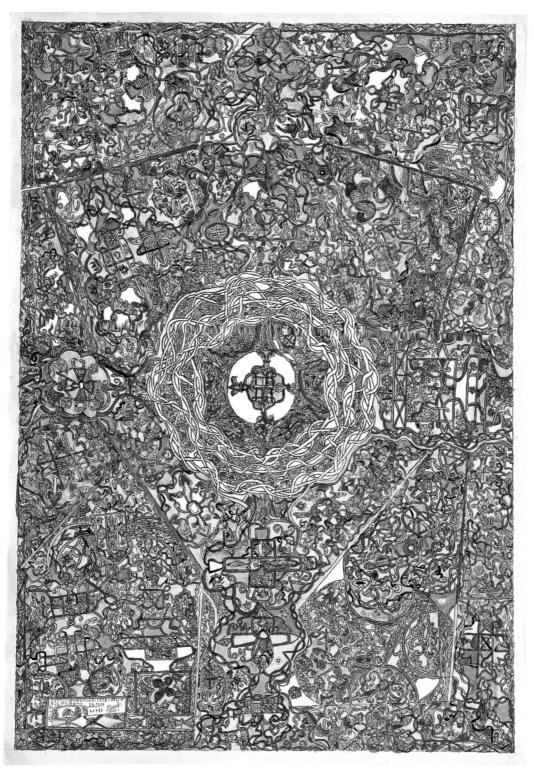

cat. 19 *Nedbén Zäpazyon*, 1998–99

SUSAN HILLER

Born 1940, Tallahassee, USA
Lives and works in London, UK

Susan Hiller studied anthropology at Tulane University in New Orleans, Louisiana where she completed a thesis based on fieldwork in Central America. After gaining a PhD in 1965, she resigned from academia and travelled extensively in Europe, North Africa and Asia. In 1969 she travelled to Great Britain and eventually settled in London.

Hiller began her artistic career in the early 1970s, when she became known for an innovative practice that included group participation in works such as *Dream Mapping* (1974); and museological/archival installations such as *Fragments* (1978), *Enquiries/Inquiries* (1973 and 1975) and *Dedicated to the Unknown Artists* (1972–76). The works were executed in a range of media including automatic writing, extra-sensory perception, photomat machines, wallpaper, postcards and other denigrated aspects of popular culture.

The common denominator in all her works is their starting point in a cultural artefact of Western society. Her work is an excavation of the overlooked, ignored or rejected aspects of our shared cultural production, and her varied projects collectively have been described as investigations into the 'unconscious' of culture. Hiller cites Minimalism, Fluxus, aspects of Surrealism and her previous study of anthropology as major influences on her work. The approaches and engagements that she has instigated have become increasingly influential in suggesting areas of investigation and models of practice for contemporary art.

In 2002 Susan Hiller was the DAAD Fellow in Berlin where, over a three year period, she developed the *J. Street Project*, a video and photographic installation and major publication, tracing the absences of German history and memory through the documentation of all the streets, lanes and country roads whose names contain the word 'Jude' (Jew).

Richard Grayson

fig. 13 *Dream Mapping (Composite Group Dream Map, August 23, 1974)*, 1974

Man knowingly approaching hairbrush

Moving to the top from sweatshop

Two dogs ascending stair

Camel

Morris

Ann

Ming Dynasty

Dreamer no. 1

Dreamer no. 2

⊙ - person not moving
⊶ - person moving
◎ } dreamer not
◉ } moving/moving

Dreamer no. 3

in sleeping bag feeling cold + damp

WANTING TO GO TO BARN

Dreamer no. 4

cat. 20 *Dream Mapping (Dream Maps, August 24, 1974)*, 1974

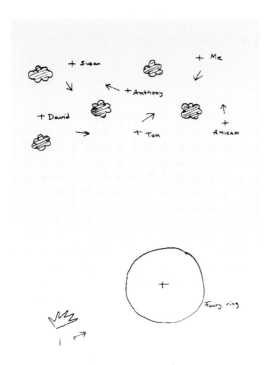

Dreamer no. 5

Dreamer no. 6

Dreamer no. 7

Composite group dream map

TEHCHING HSIEH

Born 1950, Pintong, Taiwan
Lives and works in New York, USA

> Time is both a material and content for my work. When time has
> passed, only art documents leave a trace for the work to remain.
> Art exists by itself and has its own life.[1]

Tehching Hsieh was born in Pintong, Taiwan, on 31 December 1950. He jumped
ship in Philadelphia, USA, in July 1974. He was granted amnesty in 1988, and
lives with his wife in Brooklyn.

From 30 September 1978, Tehching Hsieh was confined to a cell for one year.
From 11 April 1980 at 7pm, Tehching Hsieh punched a time clock in his studio
every hour on the hour for one year. From 26 September 1981 at 2pm, Tehching
Hsieh stayed outdoors without shelter for one year. From 4 July 1983 at 6pm,
Tehching Hsieh tied himself at the waist to Linda Montano without physical
contact for one year. From 1 July 1985, Tehching Hsieh did not 'do art, talk art,
see art', or go to galleries or museums for one year. From 31 December 1986,
Tehching Hsieh made art but did not show it publicly for 13 years.

> …because one year is the largest single unit of how we count time.
> It takes the earth a year to move around the sun. Three years, four
> years is something else. It is about being human, how we explain
> time, how we measure our existence. A century is another mark,
> which is how the last piece was created.[2]

Following their enactment, documents of these performances have been
exhibited at Jack Tilton Galley, USA (2001), the Swedish Contemporary Art
Foundation, Sweden (2002) and Centro de Arte Hélio Oiticica, Rio de Janeiro,
Brazil (2003), and have been included in numerous group shows.

> We are all taught to say everything is OK, we are in control, even
> if we are not. There is a need to be positive in public. But art is not
> doing that. We try to tell the truth in someway, to touch a part of it,
> to not be so typical. This kind of work is not about suffering, it is
> about existence.[3]

Sherman Sam

1. Tehching Hsieh in conversation with Adrian Heathfield, 2006.
2. Tehching Hsieh in conversation with Delia Barjo and Brainard Carey in *The Brooklyn Rail*,
 August/September 2003, http://www.thebrooklynrail.org/arts/sept03/tehchinghsieh.html
3. ibid.

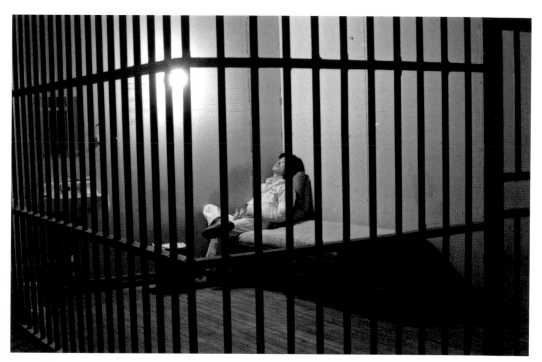

cat. 21 *One Year Performance (1978–79)*, 1979

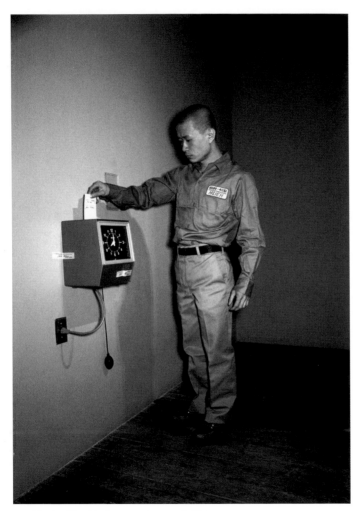

cat. 22 *One Year Performance (1980–81)*, 1981

cat. 23 *One Year Performance (1981–82)*, 1982

KATARZYNA JÓZEFOWICZ

Born 1959, Lublin, Poland
Lives and works in Gdańsk, Poland

> I comment on reality through my ordinariness. Following the
> rhythm of commonplace activities I work at home. Life and work
> interlink. Now and again the borders between them become blurred.
> Work is the result of, and a supplement to, my everyday life. It fills
> up every space ordinariness has left empty.[1]

In her domestic environment, and using readily available materials such
as newspapers and magazines, Katarzyna Józefowicz slowly and obsessively
creates extraordinary, expansive sculptures. She laboriously cuts, shapes
and glues together pages to create the basic modules that then multiply into
sprawling artworks. Her method of working could be seen to draw on a tradition
of laborious women's handwork, such as patchwork and embroidery. Created
in the privacy of her own home, Józefowicz's art practice has become part of
her household routine, one of her daily domestic tasks.

Yet Józefowicz's art is infinitely more complex and sophisticated than any
traditional handicraft. On the one hand an abstract collection of objects with
many of the formal attributes of minimalist sculpture, on the other a subtle
commentary on contemporary media and urban culture. For *Carpet* (1997–2000)
she painstakingly cut out a sea of celebrity faces from various magazines.
Hundreds of rows of images of smiling superstars are absorbed into a five by
five metre square floor piece. The overall effect suggests that the well-known
figures in contemporary society are part of a much more homogenous whole
than they might like to think.

In *Games* (2001–03), Józefowicz set out to give physical shape to the
advertising leaflets, statements and media messages that were delivered,
unsolicited, to her home; in her words, she hoped 'to bring the goods
represented back to life'.[2] She chose to transform the advertisements into
hundreds and thousands of small cubes. Spread on the floor in toppling stacks
and rows, these numerous tiny paper units resemble crumbling housing,
collapsed cities.

Almost more than the work itself, it is Katarzyna Józefowicz's working
methods that inspire awe. Her intimate, low-tech practice requires patience
verging on obsession. She channels this fixation to produce pieces that through
the accumulation and amassing of smaller parts create a larger and more
significant whole. Her passion and ability to build and to fill space quells the
mundane qualities of her original, everyday materials, and uncovers and
exposes their hidden attributes and meanings.

Rachel Kent

1. Katarzyna Józefowicz, *(The World May Be) Fantastic*, Sydney Biennale, 2002, p. 109.
2. ibid.

cat. 24 *Untitled*, 1994

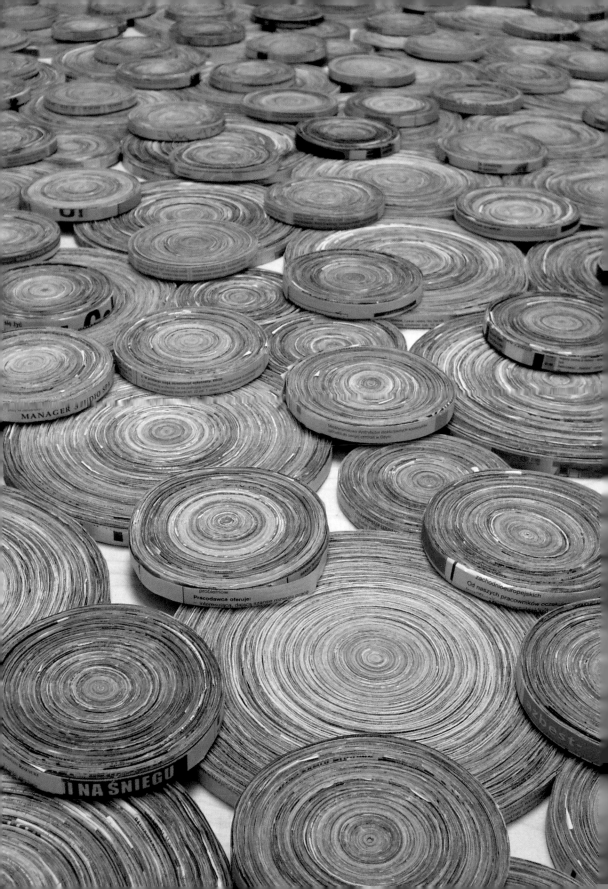

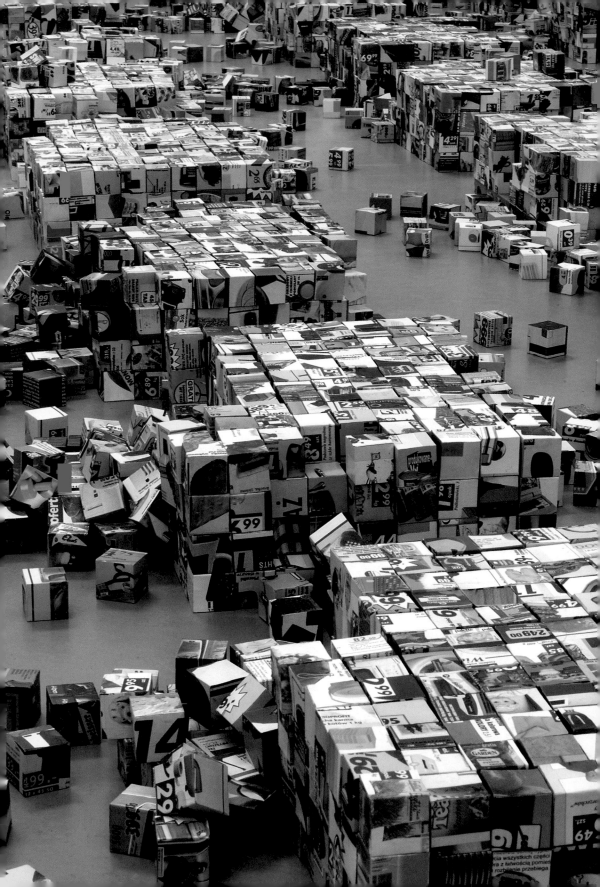

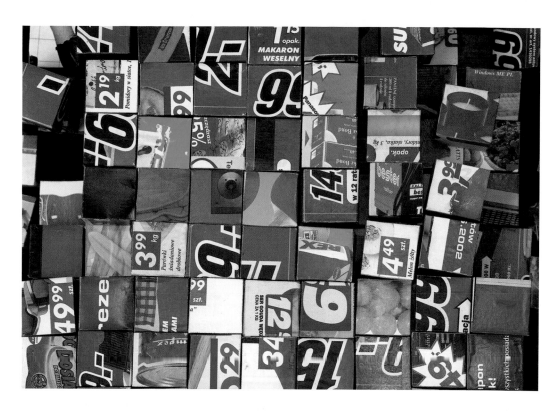

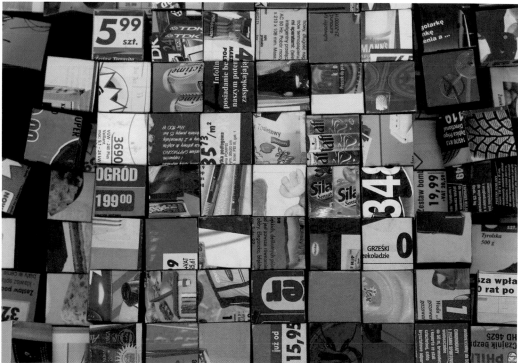

cat. 25 *Games*, 2001–03

JOACHIM KOESTER

Born 1962, Copenhagen, Denmark
Lives and works in New York, USA

Joachim Koester's works begin typically with an obscure story bound up with
a particular place and somehow fractured or layered through time. Then, in
photographic series, films or slide installations, he pieces the story together,
not to resolution, but rather to a point where various individuals, images and
ideas begin to cohere and inflect on one another across time. Koester often
accompanies his images with texts or voiceovers that elaborate on the content
of the work or recount something of the experience of making it. His subjects
are diverse, ranging from late nineteenth-century explorers, to early twentieth-
century occultists, and post-1968 radicals.

In the video installation *Sandra of the Tuliphouse or How to Live in a Free
State* (2001) (made in collaboration with the American artist and filmmaker
Matthew Buckingham), Koester focuses on Christiania, a former military
base in his native Copenhagen proclaimed a free city by anarchist squatters
in 1971. The work comments on the topical transformation of Christiania from
regimented fortress, to Utopian dream, to its present reality as a squalid
commune, using the first person narrative of a fictional character named Sandra.

Koester's film *Message from Andrée* (2005) takes as its subject Salomon
August Andrée, a Swedish polar researcher who, in 1897, attempted to cross the
North Pole in a hot air balloon. The balloon crashed north of Spitsbergen and,
32 years later, a box of negatives was found with the remains of the expedition;
some of the negatives contained images but most were filled with stains and
streaks of light. Koester re-photographed them on 16mm film to make a short
animation. '...the film points to the twilight zone of what can be told and what
cannot be told, narrative and non-narrative, document and error. A psychic
reality suggested by immaterial "black snow" that appears on the film.'[1]

1. Joachim Koester, text accompanying the film, *Message from Andrée* (2005).

ADRIAN DANNATT

Born 1963, London, UK
Lives and works in New York, USA; London, UK; the Sologne, France

Adrian Dannatt is an artist, writer and curator. He is manager of the
clandestine, anonymous conceptual-artist-fashion-model super-group who
go by the name of 'The Three' and have exhibited at Percy Miller Gallery,
Deitch Projects and Josee Bienvenu Gallery in New York. His film *Luv Uzi*
is represented by the British Council and has been shown in festivals from
Alaska to Perth, Australia.

Clare Carolin

fig. 14 *The PAN Museum*, 1999

fig. 14 *The PAN Museum,* 1999

ISBN-11: 1-85332-261-X

ISBN-13: 978-1-85332-261-7

THE PAN MUSEUM

A PROJECT BY ADRIAN DANNATT AND JOACHIM KOESTER

here was a solid, steady rain scouring
cross Manhattan, the Hudson River
velling its fat banks, late afternoon
the dying second half of a long year
ith the dusk and darkness of the storm
ruising the sky lead pencil plum. I was
anding by the window on the eighth
oor of Vestry Street, with its views over
e River, the silver Empire State inter-
ittent through rolling banks of graph-
e clouds, rain sharp and fine as etching
urr, sipping Smoked Lapsang from a
edgwood pot and pondering the na-
re of obscurity. Why was I so interest-
d in failure? And surely by association,
y tannic stain, that fascination with all
rms of failure made me one myself?
drian, I think you will love this old
inter I have just been told about…'

had received a phone call from my friend
itchell Algus on the scent of our seem-
gly continual quest for another artist even
ore obscure, more forgotten, more hidden
an the last one; an ultimate secret, her-
tic figure. For Mitchell shared my per-
rse and doubtless ultimately sadistic taste
r artists who now worked without any
parent audience, often without anyone at
to witness what they produced, pushing
those almost metaphysical boundaries of
-making where there is no real reason,

no reward in doing so.

Mitchell himself had been an artist,
showing with the fashionable Pat Hearn
Gallery in the early 1980s, when it was lo-
cated in the still very rough East Village. He
had been in various group shows with the
likes of George Condo and Peter Schuyff,
and his small sculptures had found their
collectors. Indeed the revered dealer Jack
Tilton had even boldly swapped a ripe
Richard Tuttle drawing in exchange for one
of Mitchell's *objets*.

But Mitchell was actually a scientist by
training and had enrolled early in the New
York school system, working as a profes-
sional science teacher instructing teenage
students in biology, physics and chemistry
at a large and ethnically rich working-class
Public High School out in Queens. During
the day Mitchell taught at school and in the
afternoon he drove over to Manhattan and
opened up his eponymous gallery in a tiny
SoHo storefront. Here he ran a truly eccen-
tric roster of exhibitions devoted to a wild
variety of artists who were only united by
their relative lack of commercial success, a
success he was not about to adjust upwards.
For though Mitchell's gallery was techni-
cally, ostensibly, a commercial enterprise,
it was in reality entirely subsidized by his
high-school teaching, and despite the very
occasional purchase by curious fellow art-
ists it was rare for any show to sell even one

work. This naturally just made the whole
enterprise all the more enjoyable; an al-
most absurdist exercise in precisely the sort
of ludic play that has been squeezed out
of the art world by money and real estate
– mounting exhibitions just for the sheer
intellectual pleasure, the entertainment of
doing so.

Now Mitchell knew everything about
art, from the youngest and most modish
practitioners to the names of long-vanished
museum curators, and though he had put
on group shows that introduced future stars
such as Matthew Ritchie or Lisa Ruyter, his
stronger penchant was still toward the truly
obscure. When we came upon an appropri-
ate figure, a suitably shadowy denizen of
the creative *demi-monde*, we often called
each other to verify their true rarity. On the
phone Mitchell had, as always, sounded
excited, amused. 'I've been contacted by
the daughter of this painter out in New Jer-
sey who's just died. She told me that he had
his own private museum that nobody has
ever seen, the museum was only for him:
visitors not allowed. We really *must* go out
to New Jersey to see the place, it's called
the PAN Museum!'

As if on cue, across the Hudson, New
Jersey revealed itself. Through the scud-
ding clouds a shaft of bright direct sun lit
the industrial highlands, the copper spires,
like that little patch of yellow wall, like the

warmfh still contained in the Neo-Classical jasper blue of the Wedgwood's curve.

———

So we determined to journey out to New Jersey and visit the PAN Museum. Mitchell was one of the few people I knew in New York who could drive, or who even had a car, a vehicle in which he traversed the whole country and sometimes ventured as far away as Canada in order to visit minor auction houses or once major artists. He was an expert on tertiary salesrooms over the border in East Virginia where work by his favoured early Seventies kinetic artists might be bought at very lowest bid and, like myself, a fellow devotee of bargain basement sales, we rarely ventured over $800. The fabled car was equally useful for plotting trips around the states to pay courtesy calls to Mitchell's network of artists. These were people who, due to the irresistible workings of capitalism, tended to live in remoter areas of the world and often in unusual situations, architectural and domestic. Few were youth-

ful and all were grateful. For it should be explained that though he resolutely resisted actually selling their work, Mitchell was a hero to his artists, because he cared, because he knew, just because he showed up. For these were artists who had already worked with some of the most important dealers of their time – not to mention curators and museums – artists who could acutely, accurately, grade the world's attention. And the attendant brutality of its lack.

Of course there are as many varieties and shades of failure as of success, and Mitchell was a specialist, specifically one who resisted the appeal of the 'outsider artist', those who accumulate their art over the decades without consideration for its destiny, those already marginalized by medical or socio-economic circumstance. No, these 'outsiders' were already far too well served for Mitchell's taste, they had their own successful fairs, their network of collectors and there were already numerous scouts and gallerists eagerly looking for any technically un-trained artist with a bulimic body of

work long secluded. For the model of Henr Darger, the Chicago janitor who filled h rooms with endless piled volumes of draw ings – art only discovered upon his dea – has grown from rumour and footnote, relatively little known fable, into an absolu model, a textbook example of one way live the artist's life.

The attraction of the 'Outsider' model f an artist is obviously that there is no judg ment involved. If you have deliberate decided to shun the whole world then y are completely removed from any pote tially hostile criticism or market cruelty. Y cannot be afraid of not finding an audienc not having a gallery, not selling or bei seen, bad or non-existent auction recor the judgement of your peers – all forms rejection.

By contrast the artists Mitchell dealt w had already tested themselves repeated in the real world, indeed in what might considered in Lacanian terms as the ultima 'real', the everyday commercial art mark For Mitchell specialized in artists who h

...ce been relatively famous and in fact ...uccessful', who had starred in various Bi-...nales and Quadrinales, who often had big ...useum retrospectives, solo shows at the ...hitney or MoMA to their credit, who had ...orked for decades with Leo Castelli, made ...e cover of *Life* magazine, and featured in ...ery celebrated private collection.

Thus Mitchell's programme of exhibi-...ns was, intentionally or not, like a sort of ...orality play, a three dimensional metaphor, ...vivid warning and reminder to every ambi-...us young artist in New York that their cur-...nt favour, their 'success' meant absolutely ...thing, that they could be forgotten as soon ...acclaimed.

Interestingly enough the reaction of most ...these young artists was simply disbelief, ...ey just absolutely refused to believe – de-...ite evidence of catalogues, history books ...d CVs – that these artists had really ever ...en so revered, so mainstream in their ca-...r and commercial success. For a 30-year-...d artist currently riding the crest of their ...putation, it was unacceptable, impossible,

to imagine that such attention could ever dwindle.

But the fact is that the art world is obliged to operate on a principal of built-in, auto-matic amnesia. Names must be removed, partially or totally wiped off the board, in order to make room for new ones to be continually added, there is only space for so many artists. Even with a proliferation of galleries and collectors, the sheer number of practicing artists generated every year by the schools and colleges ensures that most must be excluded from the game, if not right now then at some point in their career. For assum-ing that an artist has their first show aged 25 and that in all likelihood they may be work-ing until the age of 75, it is highly improb-able that in those full 50 years of active art making they can stay continually visible or valid.

Eking out their frugal latter years on dis-tant farms, barns agroan with the weight of stored canvases and storied sculpture, still making art every day in the studio and only later carrying this work out to join the others

in that barn, these sprightly septuagenarians hear the tootle of Mitchell's horn, lost on mi-nor routes, as he arrives.

It had occurred to me that as we were to be the first official visitors to the PAN Museum we should take a professional photographer with us to document the occasion. Better yet, perhaps to find an artist who happened to use photography for their own purposes and who would be in sympathy with the event itself. Luckily at the Greene Naftali Gallery in Chelsea I had already spent some time ad-miring the work of one Joachim Koester. His resonant photographs of a commune in his native Copenhagen managed to capture both the sad decay of its utopian dream and its remaining bohemian charms, a combination surely well suited for a posthumous one-man private museum in the deeper suburbs of New Jersey.

So we set off, with Mitchell jovial at the wheel, crossing the Hudson, negotiat-ing the outskirts of Patterson, a city famous for waterfall and poem then with some dif-

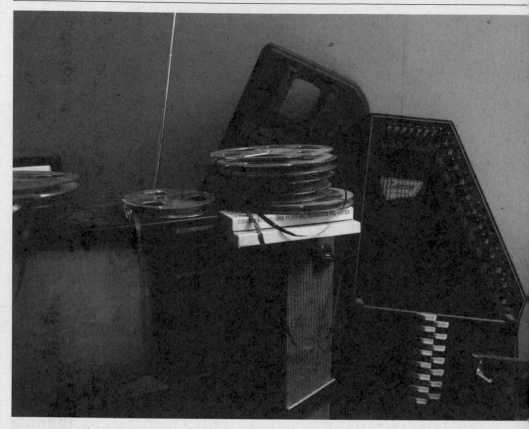

ficulty finally tracking down the right area of Denville itself. Denville NJ is a resolutely ordinary, solidly banal and completely unremarkable suburban town whose only other tenuous connection to the world of culture might be that it houses the subscription department of *The Art Newspaper*.

The PAN Museum was not easy to find, being located not even in the middle of nowhere but on its outskirts, and because it resembled a low row of shops. A long two-story building whose entire second floor was given over to the PAN Museum, it was actually a row of shops which included a Chinese take-out and a slightly dusty beauty salon. Outside this building patiently waited the current curator and keeper of this institution, one of the two daughters of the museum's late founder and sole exhibitor, namely Pietro Antonio Narducci.

Pietro Antonio Narducci, P, A, N, or P.A.N. or just plain old PAN. Here was a figure to gladden the heart of any archivist, obscuran-

tist or marginalia-fetishist, one who had been a central part of America's most celebrated artistic movement, who had known everyone who was anyone of the era, but who had then determinedly turned his back on all such activity. Narducci had all the glamour of the long-lost historical figure, the art-world insider, the Zelig-like footnote to a very famous story, that of New York 'Abstract Expressionism', and then in his later years he had himself adopted the equally tempting trope of the classic 'outsider' artist.

When William Boyd published his book on 'Nat Tate', a mysterious 'Ab Ex' painter, it was a disguised work of fiction and Boyd had no idea that exactly such a figure actually existed. No, nobody had heard of Narducci despite his status as a near-founding member of 'Abstract Expressionism'. And though Narducci had the aura of an eccentric recluse he had in fact spent years at art school, teaching and working on government commissions. He both knew and was respected by the most famous artists of his era.

Narducci was born on the 1 February 191 in Pietra Carmella, a small Italian mountai town in the Gran Sasso, where he could s into the front room of his parent's house He was largely raised by priests at th Catholic Church next door. His father le for America to escape Mussolini's recrui ment drive, and Narducci joined him ther when he turned 15. Based in New Jersey, h had enrolled at the Leonardo da Vinci A School in Manhattan, moving in 1936 t the Beaux-Arts Institute of Design to stud sculpture. Having subsequently studie fresco restoration at the Metropolitan Mu seum, he began working as a Federal Ar Project painter, in the WPA (Works Projec Administration) Mural Division and wa nominated for the Prix de Rome for one o his gigantic frescoes. This work was show at the Grand Central Gallery along wit work by Isamu Noguchi and other lumi naries. Narducci's classical fresco of wil stallions was painted on a concrete wall s heavy it had to be delivered to the uptow gallery by horse-drawn wagon. When th

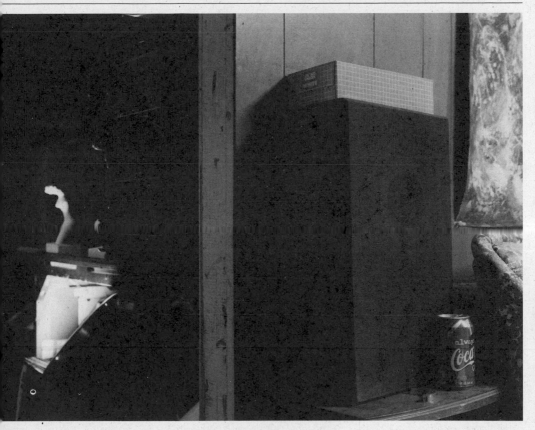

ow ended, the gallery did not know what
do with such a monumental work so they
t loose jealous students with sledgeham-
ers who completely destroyed it. It was
e very last time Narducci exhibited in
ublic.

The two catalysts for Narducci's dis-
overy of 'Abstract Expressionism' were,
st being introduced to Stravinsky's *Rite
Spring* by an opera singer girlfriend,
d then being led one day into the Cedar
avern, that notorious and fabled artists'
atering hole in downtown Manhattan.
s regular roster of nascent stars included
ckson Pollock, Willem de Kooning,
am Francis and Franz Kline, the latter
coming Narducci's closest friend in the
roup, and indeed outside of it. Narducci
as known as 'Tony' rather than Anto-
o and his Cedar Tavern nickname was
he Lizard' or 'New Jersey Lizard from
e swamps' as he commuted to the bar
om Denville. He was also known as 'The
rince' because of his aristocratic airs.

Along with art the great love of Nar-

ducci's life was his wife, who went by the
stage name of Muriel Koud Reed, an Irish-
Catholic–Russian–Jewish ballerina from
a theatrical family. It was only after they
married in 1943 (his best man being the
then curator of the Guggenheim Museum)
that he discovered she could speak Eng-
lish. The marriage did not work out, and in
1953 he was crushed by the simultaneous
blow of divorce and the accidental death of
his five-year-old only son.

In many ways this period was a turn-
ing point. Several of his old artist friends
were already dead. The last time he had
seen de Kooning the two of them sat on
a New York sidewalk sharing a pastrami
sandwich, then de Kooning drove back to
the Hamptons and Narducci to New Jer-
sey, neither of them to return to the city.
Elaine de Kooning's words in a letter to
Narducci described both artists' situation
well; 'Bill too, is a recluse and never visits
the city. He just wants to stay in his stu-
dio and paint.' That was also all Narducci
wanted to do, but unlike de Kooning he

was unfortunately obliged to work at vari-
ous jobs, such as antique dealing in order
to make ends meet. Planning to join the
American Air Force he discovered he had
signed up for American Airlines instead.
There he was employed as a graphic art-
ist and painter, and improbable as it may
seem he actually designed the company's
famous logo of the eagle that is still in use
today.

Eventually Narducci was able to retreat
into self-imposed exile in his museum, fix-
ing, solidifying his existence in these small
rooms in which he did nothing but dedicat-
edly make art for a full 60 years. Up the
narrow stairs on the second floor, the PAN
Museum is a tight warren of very modest
chambers, many sub-divided and without
windows, the walls thick with amateur
stucco and the low ceilings thick with ac-
cumulated tobacco smoke. The place is
labyrinthine, oppressive, dark, narrow and
magical. It is full of art, of course, and also

full of the larger wonder of art, the impulse to create images, to create one's own world, the God thing even.

Narducci himself was all too aware of the mystic, galactic and universal dimensions of his tight, crowded set of rooms in Denville. If his painting style had already changed from Neo-Classical to the 'Abstract Expressionism' of his *Nebula* series of 1954 and cast-concrete sculptures entitled *Apollonian*, it then shifted dramatically again. On his fire escape, through an open kitchen door at the back of the building, Narducci set up an oscilloscope wired to a camera which he kept pointing into the sun, and thus began painting directly with light and sound waves. These surely constitute the first ever paintings created with the energy of the sun: abstract images captured on film and transformed into cybernetic paintings and a huge sculpture such as one called *Cosmic Woman* which was even wired for sound. For Narducci never ceased to try new techniques, and considered his personal breakthrough to the 'next step' of purest creativity came in 1985 when he began using acrylics mixed with rainwater and ammonia, elements of the universe taken directly from nature. These 'Quintessential Aesthetics' occupied him until his death, a secret shared only with his children.

Who else saw these works? Who saw his ideas in free evolution? Narducci had on occasion taken the rare Denville student for art lessons, but increasing agoraphobia and sensitivity to the cold soon ensured he rarely left his quarters and would even take a taxi to visit his dentist just a few streets away. The PAN Museum, the culmination of all his creative labours, was not open to visitors or maybe it was simply that nobody wished to visit, nobody cared. But every single evening, each night of the year, Pietro Antonio Narducci would chose just one of his most recent paintings and take it to the one window that faced the street. He would hang the chosen painting there in the spot lit window of his museum, for the townspeople of Denville, for anyone who might look up and see it hung in the only venue in the world he could trust to show his work in exactly the way he wanted. Every night a different painting, one painting in one window, a single rectangle of light. **Enough.**

THE PAN MUSEUM: A PROJECT BY
ADRIAN DANNATT AND JOACHIM KOESTER

Published on the occasion of the exhibition:
A Secret Service:
Art, Compulsion, Concealment
Organised by Hayward Gallery Touring
in collaboration with the Hatton Gallery,
University of Newcastle

TOUR DATES

Hatton Gallery, University of Newcastle
17 September – 11 November 2006

De La Warr Pavilion, Bexhill on Sea
27 January – 15 April 2007

Whitworth Gallery, University of Manchest‹
5 May – 29 July 2007

COLOPHON

Exhibition curated by Richard Grayson
Organised by Clare Carolin, assisted
by Rachel Kent and Sherman Sam

Published by Clandestine Press in associa-
tion with Hayward Gallery Publishing,
South Bank Centre, London SE1 8XX, UЬ

Graphic design by Maureen Mooren &
Daniel van der Velden, Amsterdam, based c
the format of Newspaper Jan Mot, Brussels

Printed by Cultura, Wetteren

Adrian Dannatt and Joachim Koester
would like to thank Mitchell Algus.

fig. 14 *The PAN Museum*, 1999

PAUL ÉTIENNE LINCOLN

Born 1959, London
Lives and works in New York, USA

Paul Étienne Lincoln creates elaborate installations, allegorical machines which investigate subjects as varied as the court of Louis XV at Versailles, or the technological infrastructure of New York City. The installations, produced over a period as long as a decade, are often predicated upon a literary or historical figure. *The Purification of Fagus sylvatica var pendula* (2001) focuses on Samuel Bowne Parsons and the tree that he planted in Queens, New York. The following is an extract from a text by Lincoln describing the background to the pavilion and the objects in it that were created for the performance documented in the photographic series and film entitled, *Passage to Purification* (2001):

> Situated at the perimeter of the Weeping Beech Tree Park at Kingsland House, is a small pavilion looking onto the stump of the oldest Weeping Beech in America. In 1847 Samuel Bowne Parsons, a Quaker and Nurseryman purchased a shoot of Weeping Beech, *Fagus sylvatica var pendula*, in Belgium while traveling in search of unusual plants. On his return to the United States he planted the shoot at the site of the stump. Every Weeping Beech in America is descended from this one tree. Regrettably the stump is all that remains, as following this venerable tree's 150th anniversary in 1997, it died and was cut down. The tree had, however spawned seven progeny, which still grow in a circle around the original beech.
>
> The pavilion houses a steel smoke buoy, a glass distillation device perched on a section of the original stump, and a glass vessel containing a crystal. The still is no longer operational, but was used to distill the beech smoke extracted from the steel buoy to obtain wood creosote which has antiseptic, anesthetic, and preservative qualities, and has been used to preserve tissue in mummification.
>
> This preservative now resides at the front of the pavilion in a glass vessel, symbolically placed between the tree stump and the still. Over a two-month period the liquid will undergo a purification process, yielding a crystal of guaiacol seeded around an engraved beechnut. Crystallization is a purifying process: by using the saturated solution to adhere to a 'seed', like a grain of sand in an oyster, a pure crystal may be obtained, as the solution will always seek to sequester itself, and accumulate, as mother of pearl is layered upon itself to form an even larger pearl. A 16mm black and white film was made during the distillation performance showing a figure dressed in a cloak made from hundreds of beech leaves and a hood adorned with beech leaf casings.[1]

Clare Carolin

1. Paul Étienne Lincoln, text accompanying, *The Purification of Fagus sylvatica var pendula* (2001).

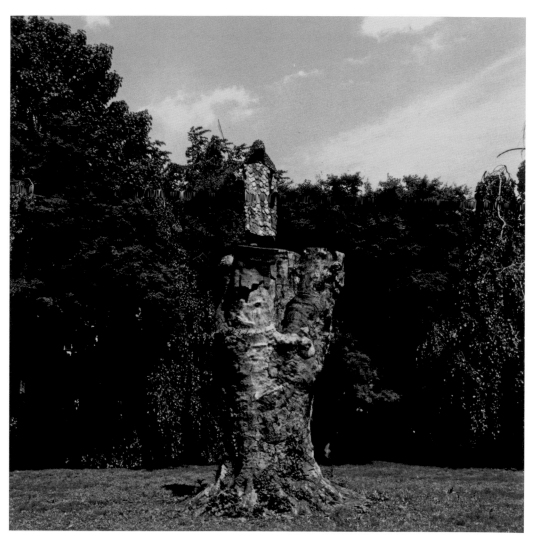

cat. 27 *Passage to Purification*, 2001

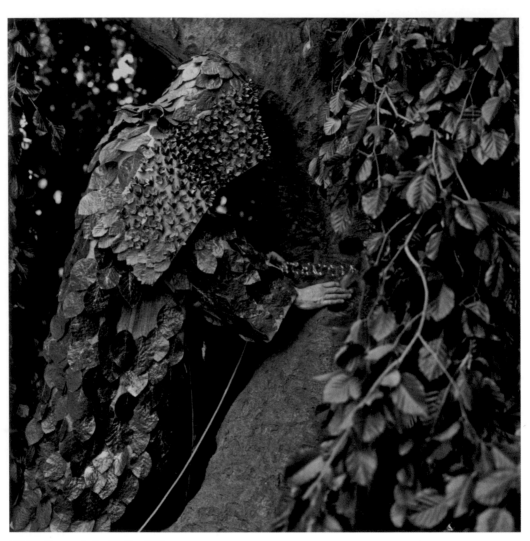

cat. 27 *Passage to Purification*, 2001

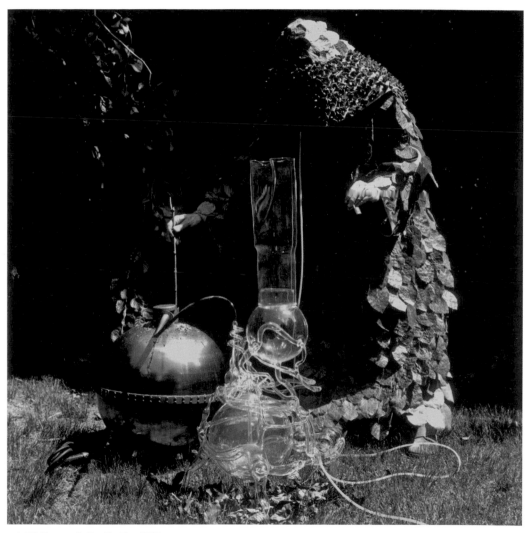

cat. 27 *Passage to Purification*, 2001

MARK LOMBARDI

Born 1951, Syracuse, USA
Died 2000, New York, USA

In 1973, while still an undergraduate at Syracuse University, Mark Lombardi worked as a researcher on the exhibition *Teapot Dome to Watergate*. Organised by the Everson Museum in Syracuse, the exhibition examined various government scandals from the 1920s onwards through a variety of media. Motivated by the ongoing Watergate scandal, it included a live telecast of the Senate hearings on the affair. The Everson's Director James Harithas considered Lombardi's work on the exhibition to be excellent and when, in 1975, Harithas was appointed Director of Houston's Contemporary Art Museum, he hired Lombardi as a curator. Lombardi maintained this position for two years leaving to take up a post as a general reference librarian at the Fine Arts Department of the Houston Public Library, which allowed him to develop his own painting and pursue his research interests. During this period he wrote two unpublished manuscripts: a study of nineteenth-century panorama painting, and an investigation into Reagan's 'war on drugs'.

In the early 1990s Lombardi turned his attention to political and financial scandals and corruptions, gathering information about them on thousands of filing cards that he configured into ever more complicated systems. It was while speaking to a lawyer friend, Leonard Gumport, that Lombardi hit upon the idea of using flow diagrams to articulate this information.

> Adnan Khashoggi was the Saudi commercial agent and playboy arms dealer who had figured prominently in the Iran-Contra affair and had made large investments in the U.S., including in Houston. As Gumport spoke, I began taking notes, then sketching out a simple tree chart, showing the breakdown of Kashoggi's American holdings. Within days, I began making more of these charts, depicting other corporate networks I had researched.[1]

As a result of this encounter Lombardi abandoned the Neo Geo abstractions that he had been painting and began creating meticulously drawn and written works that transformed facts into images. In 1997 he relocated to New York and that same year his drawings were exhibited to acclaim at the city's Drawing Centre. Other shows followed and, as they did, the scale and sophistication of his pencil drawing schematics increased. He committed suicide in his studio apartment in Williamsburg in March 2000. A few weeks after 11 September 2001, an FBI agent investigating the attacks on New York and Washington D.C. telephoned the Whitney Museum of American Art and asked to see the Lombardi drawing on display there, *BCCI, ICIC & FAB 1996–2000* (2000) that traced influences and links between global finance and international terrorism.

Richard Grayson / Sherman Sam

1. Mark Lombardi quoted in Robert Hobbs, *Mark Lombardi, Global Networks, Independent Curators International*, New York, 2003, p. 33.

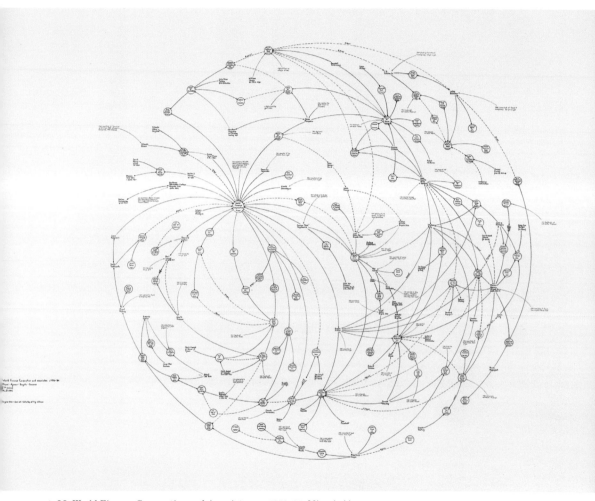

cat. 28 *World Finance Corporation and Associates, ca. 1970–84: Miami, Ajman, and Bogota – Caracas (Brigada 2506: Cuban Anti-Castro Bay of Pigs veteran) (7th version)*, 1999

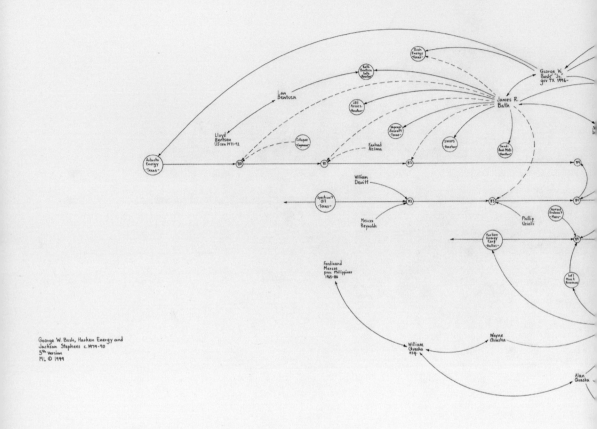

cat. 29 *George W. Bush and Harken Energy and Jackson Stephens (5th version)*, 1988 (detail)

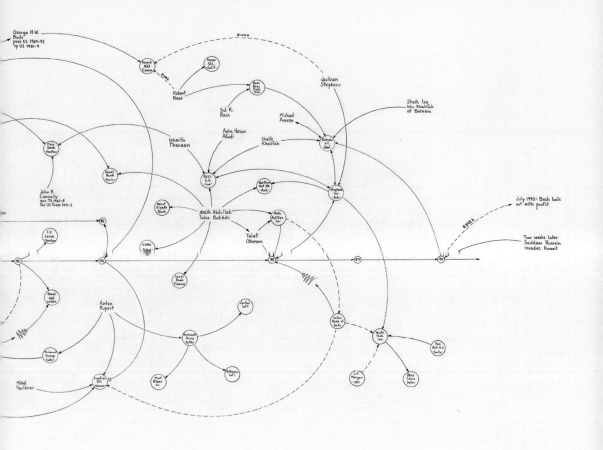

The third is Naso; Lucan is the last.

Because they all that appellation ~~~

Well it's like this, me that is Adam plus me
other organs retrieved our senses after a good
ezmek- bloodied nose, blackened goz and denim
pantalons shredded, a day as normal as any day
might be.
As to the identity of my brethren organs, of
course:- Patrik the loyal, supping fuel with

 This story is fiction. I have heard a legend that there
might have been men like them, but nowhere in the
archives of the United States Government, or in its
military history did I find it recorded. E.M.N.

incontinent visagog at the fleshpot journals,
Roman, with the brains, koking devils' fingers
and giving the evil eye, and for finale; Noel
as nasty as nastiness comes and only bought out
for occaisions ozel- one of which having just
honoured our merry banda........ and of that
banda, it's isim: The 'AMNESIACS', a title
quite perty in this the glowing embers of the
premier yuzyil of the third binyil A.D. (Of
course Roman was the Organ that wove this thread
arlati, and quite a story too)
Premier, to peynt a full and realistic tablo
me must endeavour to supply the arka-plan; the
painted sheets in front of which the 'AMNESIACS'
and their arlati might unfold. So here goes.

~~~ ey judge."

~~~ held,

~~~ ed:

~~~ ne;

~~~ en gates,

~~~ und

¹ *The monarch of* ~~~ from a passage in the ~~~ Convito," that there was no Latin translation of Homer in Dante's time. "Sappio ciascuno," &c., p. 20. "Every one should know that nothing, harmonised by musical enchainment, can be transmuted from one tongue into another without breaking all its sweetness and harmony. And this is the reason why Homer has never been turned from Greek into Latin, as the other writers we have of theirs." This sentence, I fear, may well be regarded as conclusive against the present undertaking. Yet would I willingly bespeak for it at least so much indulgence as Politian claimed for himself, when, in the Latin translation which he afterwards made of Homer, but which has since unfortunately perished, he ventured on certain liberties, both of phraseology and metre, for which the nicer critics of his time thought fit to call him to an account: "Ego

vero tametsi rudis in primis non adeo tamen obtusi sum pectoris in versibus maxime faciundis, ut spatia ista morasque non sentiam. Vero cum mihi de Græco pæne ad verbum forent antiquissima interpretanda carmina, fateor affectavi equidem ut in verbis obsoletam vetustatem, sic in mensurâ ipsâ et numero gratam quandam ut speravi novitatem." Ep. lib. l., Baptistæ Guarino.
² *Fitter left untold.—*
 "Che'l tacere è bello."
So our poet, in Canzone 14 :
 "La vide in parte che'l tacere è bello."
Ruccellai, "Le Api," 789 :
 "Ch' a dire è brutto ed a tacerlo è bello."
And Bembo:
 "Vie più bello è il tacerle, che il favellarne."
 Gli Asol., lib. i.

ONWARD HE MOVED, I CLOSE HIS STEPS PURSUED.

Canto I., line 122.

fig. 16 Notebook, 2006, *AMNESIAC SHRINE or Double coop displacement*, Matts Gallery, London

KURT SCHWITTERS

Born 1887, Hanover, Germany
Died 1948, Kendal, UK

Kurt Schwitters' practice covered many media: performance, poetry, typography, painting, sculpture and collage. Although he was associated with contemporary movements such as Dada initially, and later the Bauhaus, he maintained his distance from them, preferring instead to develop his work from 1919 onwards as *Merz*. *Merz* used found, discarded and over-looked scraps of image, paper, text and objects and assembled them into compelling collages and sculptures in ways that drew the world outside into the matter and material of the artwork. The concept grew to cover the full range of his activities: the *Merzbauten* – complex architectural installations that he constructed in different private buildings in Germany, Norway and the UK, his ideas for a *Merztheater*, the *Merz* magazine which he published from 1923–32, and his advertising agency, the *Merz Werbe*. Through these activities he said that he was seeking to create a *Merzgesamtweltbild*, or 'total *Merz*-world', that embraced all art forms.

In the 1920s, Schwitters' poem *An Anna Blume* became one of the best known verses in Germany, while the *Ursonate* – which he began in 1924 and continued to develop for the next 20 years – is considered one of the most important and influential performance/poetry sound works of the twentieth century. Schwitters exhibited his work in Europe and in America from 1920 onwards. In 1936 his work was shown for the first time at the Museum of Modern Art in New York.

In 1937, developments in Germany compelled him to emigrate to Norway. The same year, four of his works were included in the *Entartete Kunst* exhibition in Munich: a display by the Nazis of what they considered to be 'degenerate art'.

When Nazi troops invaded Norway in 1940, Schwitters fled to England where he was interned on the Isle of Man until 1941. After his release from the camp he moved to London and from there to Ambleside in the Lake District. In 1943 the *Merzbau* that he had built in his parents' house in Hanover was destroyed in an Allied bombing raid.

Schwitters died in Kendal in 1948, having started his final *Merzbau* project – the *Merzbarn* – in the nearby village of Elterwater.

Richard Grayson

cat. 30 *Merzbau (Barbarossa Grotto, probably identical with Kyffhäuser)*, 1925

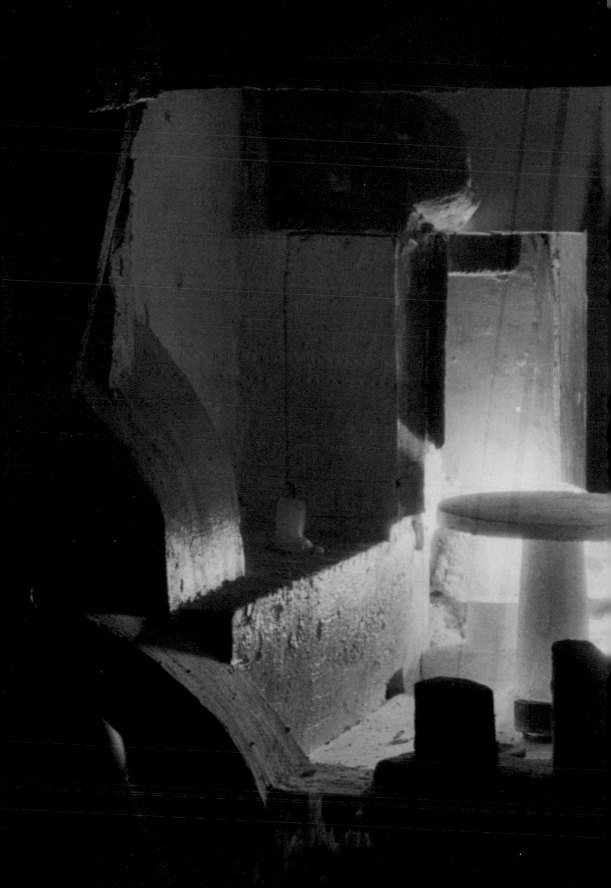

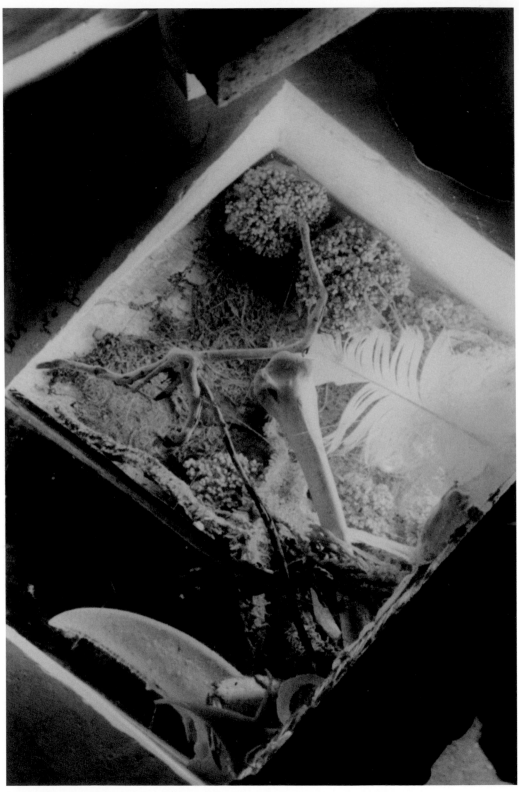

cat. 31 *Merzbau (Grotto in memory of Molde)*, 1935

cat. 32 *Merzbau (detail with Madonna), c.*1930

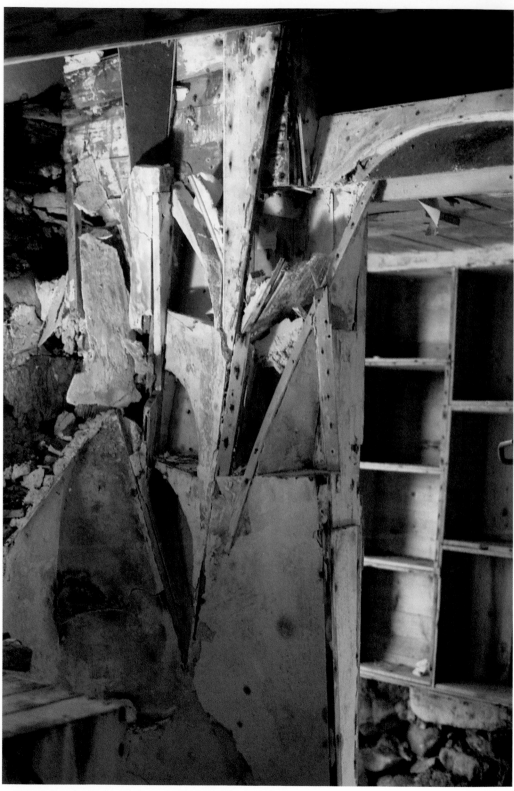

cat. 33 *Cottage on Hjertøya (interior view, towards west, detail of 'Ofenecke'),* 2001

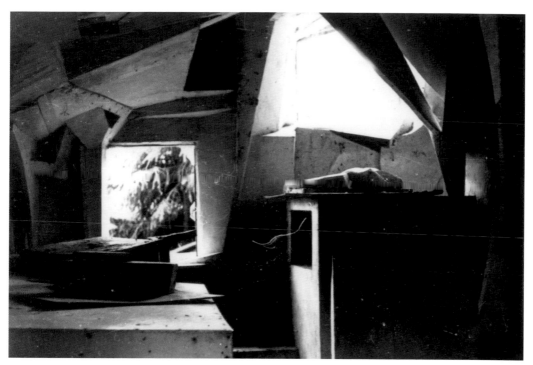

cat. 34 *Cottage on Hjertøya (interior view towards south)*, 1953

THE SPECULATIVE ARCHIVE

Julia Meltzer, born 1968, Los Angeles, USA
David Thorne, born 1960, Boston, USA
Live and work in Los Angeles, USA

The Speculative Archive produces video, publications and installation projects that focus on shifts and changes in the dynamics of power; how people live in relations of political violence, and how the effects of violence are produced, recorded, saved, recollected, and represented. The Speculative Archive was founded by artists Julia Meltzer and David Thorne in 1999, and since then has developed two bodies of work. The first focused on state secrecy practices, memory, and history. The second on the use of documents – images, texts, objects, bodies, and physical structures – to project and claim visions of the future in a time of 'war on terror'. Much of this recent work is based on a year spent living and working in Damascus, Syria.

In 2001 The Speculative Archive conducted a series of interviews with government officials involved in the regulation and release of secret government information. Below is an excerpt from one of these interviews:

THE SPECULATIVE ARCHIVE: Could you state your name and position?
CHARLIE TALBOT: My name is Charlie Talbot. My position is the Deputy Director of the Directorate for Freedom of Information and Security Review in the Pentagon.
TSA: How does someone formulate a request for a document pertaining to a specific subject? Are they assuming the secret materials must exist?
CT: People who make a request are informed because they know that there is something on the subject matter. They don't know exactly what sometimes, but they know there is something. To give you an example, every time we have a military conflict anywhere in the world, you can expect a Freedom of Information Act (FOIA) request to come in later for all the records related to that. The best example I can give you is near the end of Jimmy Carter's administration, when we had the hostages in Iran and the aborted attempt to rescue them. After that *The Washington Post* came in and asked for everything on the planning – everything – and it was, at that time, paper stacked end to end, about thirty-two linear feet of paper for the planning of that raid. Just the planning. So they wanted everything on that – they wanted thirty-two feet of top-secret information. To make a long story short, we went into FOIA litigation, which took ten years to litigate through the court, and what we released finally was a stack of papers this high, about one linear foot, that was redacted heavily, and also some maps on the raid. That took ten years of litigation.
TSA: Has the rest of that material subsequently been declassified?
CT: I have absolutely no idea, I don't know where it is or what happened to it.

Clare Carolin

cat. 35 *It's Not My Memory of It*, 2003 (film stills)
Top: A CIA film recorded in 1974, but not acknowledged until 1992,
documents the burial at sea by the CIA of six Soviet sailors
Bottom: Images pertaining to a publicly acknowledged but top-secret
US missile strike in Yemen in 2002

Golden Gate Bridge, San Francisco, California
Ghasoub al-Abrash Ghalyoun, 1997

cat. 36 *In Possession of a Picture: a selection of incidents of photographing or videotaping persons of interest at various sites of interest, referenced with images from other sources*, 2005

Gary Ewr
http://www.prosoft.force9.co.uk/
backgrounds/america/golden%20gate
%20bridge%201024x768.jpeg

JEFFREY VALLANCE

Born 1955, Redondo Beach, USA
Lives and works in Los Angeles, USA

In 1977, Jeffrey Vallance gained notoriety for getting his work included in the collection of the Los Angeles County Museum of Art by posing as an electrician, installing electrical sockets in the members' room, ('painted with stupid little scientific scenes … like microscopes and dinosaurs'), and then throwing a private view for his 'exhibition' complete with invitations and press release. This event, together with the burial and exhumation of *Blinky the Friendly Hen* (1978), a frozen supermarket chicken purchased and named by Vallance and interred in a ceremony at the Los Angeles Pet Cemetery – sealed his eccentric reputation. Still based in Los Angeles, Vallance and his work fit somewhere between merry prankster-ism, cultural anthropology, nerdy collecting, religious phenomena and eclectic museology.

Vallance is a regular contributor to the *Fortean Times* – a journal of strange phenomena – and *The LA Weekly* (a free and popular listings newspaper). He is also the co-creator (with his curatorial students) of the website, Preserving America's Cultural Heritage (http://www.americasculturalheritage.us/) which proposes a solution to the lack of an effective cultural policy on the federal level through a one per cent tax on the sale of all art in the United States to fund a programme to benefit individual artists. More important though are Vallance's paintings, drawings, videos and writing which are all distinguished by a scholarly anthropological approach tinged with mischief and naïve curiosity. For example, his *Richard Nixon Museum* (1991) features hash pipes in the shape of Nixon and roach clips with the image of Nixon on them.

From Liberace to the Virgin of Guadalupe, George Washington to the King of Tonga, Vallance's scrutiny provides penetrating but off-kilter commentary on the various cultures he has visited; but its real effect is to throw light upon the culture from which he himself emanates. *My FBI File* (1981) touches on the US Government's sensitivity to conspiracy, while his talismanic piece, *Blinky*, uses humour to comment on death, religious ritual and consumer culture. This is how Vallance describes the *Blinky* action:

> … we went out to the grave which was surrounded by Astroturf.
> I guess it must really be terrifying to see dirt when something is
> being buried, because then you think of the earth and all these
> terrible implications, so they had Astroturf. Then they brought the
> coffin out and I thought it would have Blinky's name written on it,
> but it had my name written on it instead. It was scary, like seeing my
> own burial! Then they lowered it down into the grave and concluded
> the ceremony. After we buried Blinky I went to the Howard
> Johnsons nearby and had the 'Chicken Special'![1]

Sherman Sam

1. Jeffrey Vallance in conversation, in *RE/search #11: Pranks*, RE/search, San Francisco, 1984, p. 62.

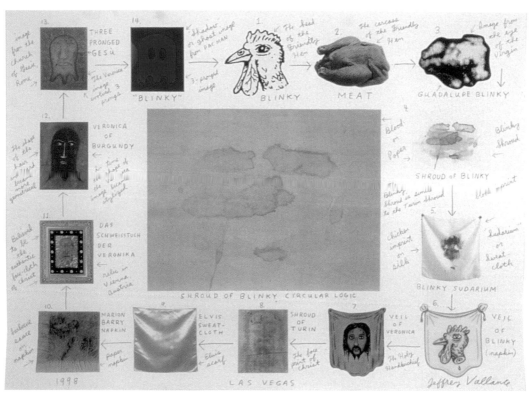

cat. 37 *Shroud of Blinky Circular Logic*, 1998

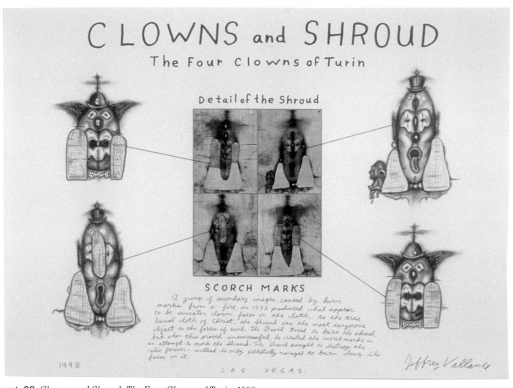

cat. 38 *Clowns and Shroud, The Four Clowns of Turin*, 1998

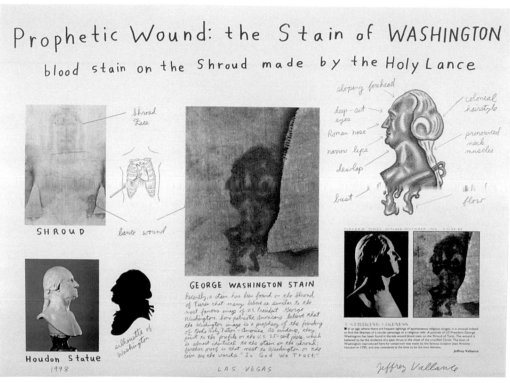

cat. 39 *Prophetic Wound: The Stain of Washington, Blood Stain on the Shroud made by the Holy Lance*, 1998

OSKAR VOLL

Born 1876, Bad Blankenburg, Germany
Died after 1935, place unknown

The life and work of the German psychotic artist Oskar Ferdinand Heinrich Voll
remain a mystery. We know from medical records that he was born in 1876 at
Bad Blankenburg to the north of the Thuringian Forest, that he was Protestant,
never married and worked as a journeyman tailor. His pictures suggest some
experience of military life, and it is possible his psychosis emerged during
active service in the First World War. There is no record of the date of his
hospitalisation, though this probably took place in his late 30s, when
Voll entered the regional asylum at Werneck in north-west Bavaria.

Voll's diagnostic record mentions schizophrenia, dementia with periodic
states of agitation, and paranoia, the implication being that he was incurable.
He was last heard of in 1935, when he was 59 and still a patient at Werneck.
Although the date of his death is not known, it is unlikely that he escaped the
Nazi euthanasia programme, for in October 1940, the entire population of the
Werneck institution was dispersed to other asylums for 'treatment', which
meant death by lethal injection, gassing or starvation.

Fortunately, Voll's artwork had been preserved when, in about 1920, his
doctors sent a large batch of his drawings to the psychotherapist and art
historian Hans Prinzhorn. As a young doctor, the latter had been asked to
extend the art collection of the university clinic at Heidelberg and spent
three years studying material sent in from psychiatric institutions across the
German-speaking territories: given that most items arrived by post, the bulk
of the collection consists of works on paper. Internationally known today as the
Prinzhorn Collection, it formed the basis of the pioneering monograph *Bildnerei
der Geisteskranken (Artistry of the Mentally Ill)* of 1922. Lacking information
about the patient, Prinzhorn simply refers to Voll as 'Case No. 33' and squeezes
six of his drawings onto a single page above the caption *Shadow Figures*.

Evidently an autodidact, Voll drew on separate sheets as well as filling
several sketchbooks (probably school exercise books) with his obsessional,
stereotyped imagery. He used a soft lead pencil that creates a lush, shiny
surface. Many sketchbooks comprise dozens of near-replicas, achieved by filling
in the outlines created by insistent pressure from the previous page. These
serial images are dominated by cavalry and artillery officers in full uniform with
splendid epaulettes, buttons and swords. Sentinels and horsemen are typically
rendered in emphatic silhouette within queerly radiant spaces. Incongruities
include Red Indians with head-dresses and tomahawks and a strange shadow
figure with a featureless globular head. A narrow strip of black sky with a moon
appears along the top of many scenes. Oskar Voll's frozen tableaux remain
untitled and unexplained, yet exert a compelling fascination.

Voll
p. 47, fig. 11

Roger Cardinal

cat. 40 *Notebook No. 7* (Inv. 344) folio 4 recto, 1910–20

cat. 41 *Notebook No. 9* (Inv. 360) folio 4 recto, 1910–20

cat. 42 *Notebook No. 9* (Inv. 360) folio 19 recto, 1910–20

LIST OF WORKS

All measurements are in centimetres, height × width × depth.

Those works without cat. numbers are included in the exhibition, but not reproduced in this book.

cat. 8, p. 51
Sophie Calle
The Hotel, Room 28, 1981
Photograph and text on paper
2 panels, each 102 × 142 × 26
Courtesy Tate. Presented by the Patrons of New Art through the Tate Gallery Foundation 1999
© ADAGP, Paris and DACS, London 2006
Image © Tate, London 2006

cat. 9, p. 52
Sophie Calle
The Hotel, Room 29, 1981
Photograph and text on paper
2 panels, each 102 × 142 × 26
Courtesy Tate. Presented by the Patrons of New Art through the Tate Gallery Foundation 1999
© ADAGP, Paris and DACS, London 2006
Image © Tate, London 2006

cat. 10, p. 53
Sophie Calle
The Hotel, Room 44, 1981
Photograph and text on paper
2 panels, each 102 × 142 × 26
Courtesy Tate. Presented by the Patrons of New Art through the Tate Gallery Foundation 1999
© ADAGP, Paris and DACS, London 2006
Image © Tate, London 2006

Sophie Calle
The Hotel, Room 47, 1981
Photograph and text on paper
2 panels, each 102 × 142 × 26
Courtesy Tate. Presented by the Patrons of New Art through the Tate Gallery Foundation 1999
© ADAGP, Paris and DACS, London 2006
Image © Tate, London 2006

Roberto Cuoghi
Foolish Things, 2004
DVD on monitor
5 minute loop
Courtesy Galleria Massimo De Carlo

Roberto Cuoghi
Untitled, 2005
Lenticular print
56 × 52
Courtesy Galleria Massimo De Carlo

cat. 14, p. 58
Henry Darger
At Jennie Richie, at shore of Aronburg Run River storm comes on anew, 206 B, date unknown
Watercolour, pencil, collage and carbon tracing on paper
60.9 × 274.4
Courtesy Kiyoko Lerner
© Kiyoko Lerner 2006

Henry Darger
At Jennie Richie going out of shelter as storm abates tree is stuck by lightning, 276 B, date unknown
Watercolour, pencil, collage and carbon tracing on paper
60.9 × 274.4
Courtesy Kiyoko Lerner
© Kiyoko Lerner 2006

Henry Darger
At Jennie Richie they admire the beauty of tropical nimbus, 102 A, date unknown
Watercolour, pencil, collage and carbon tracing on paper
58.4 × 266.7
Courtesy Kiyoko Lerner
© Kiyoko Lerner 2006

Henry Darger
At Jennie Richie they enter without torchlight and in darkness lose themselves in a volcanic cavern, 288 A, date unknown
Watercolour, pencil, collage and carbon tracing on paper
60.9 × 281.9
Courtesy Kiyoko Lerner
© Kiyoko Lerner 2006

cat. 7, p. 49
Henry Darger
Blandanion Blengin or Tuskorhorian 517-B, date unknown
Watercolour and pencil on paper
22.9 × 30.5
Courtesy Kiyoko Lerner
© Kiyoko Lerner 2006

Henry Darger
General Jack Ambrose Evans in a Glandelinian Uniform, 900 G-W A, date unknown,
Watercolour and pencil on paper
38.7 × 28.6
Courtesy Kiyoko Lerner
© Kiyoko Lerner 2006

cat. 11, p. 57
Henry Darger
General Thomas Phelan Tamerlene, General Black Brooks, General Estrabrook Starring, 900 G-M, date unknown
Watercolour and pencil on paper
29.9 × 35.6
Courtesy Kiyoko Lerner
© Kiyoko Lerner 2006

cat. 13, p. 58
Henry Darger
Goodness didn't you kids ever see a flower this big, 260 A, date unknown
Watercolour, pencil, collage and carbon tracing on paper
60.9 × 274.4
Courtesy Kiyoko Lerner
© Kiyoko Lerner 2006

Henry Darger
Hollestinian Flag of Glandelinia 14 F-D, date unknown
Watercolour and pencil on paper
35.6 × 43.2
Courtesy Kiyoko Lerner
© Kiyoko Lerner 2006

Henry Darger
Naval Flag of Glandelinia 14 F-I, date unknown
Watercolour and pencil on paper
35.6 × 43.2
Courtesy Kiyoko Lerner
© Kiyoko Lerner 2006

Henry Darger
The Heart RM-39, date unknown
Watercolour and pencil on paper
35.6 × 27.9
Courtesy Kiyoko Lerner
© Kiyoko Lerner 2006

cat. 12, p. 57
Henry Darger
Then true character was discovered, but when the Glandelinians were taking them from the camps in an auto, the machine got troublesome and this enabled the little girls to so easily get away, 500 A, date unknown
Watercolour, pencil and carbon tracing on paper
48.3 × 61
Courtesy Kiyoko Lerner
© Kiyoko Lerner 2006

cat. 15, p. 61
Henry Darger
Untitled, (Landscape with cacti and rock formations), 282 A, date unknown
Watercolour, pencil, collage and carbon tracing on paper
60.9 × 266.7
Courtesy Kiyoko Lerner
© Kiyoko Lerner 2006

cat. 16, p. 61
Henry Darger
Untitled (Tree struck by lightning and butterfly winged blengin), 282 B, date unknown
Watercolour, pencil, collage and carbon tracing on paper
60.9 × 266.7
Courtesy Kiyoko Lerner
© Kiyoko Lerner 2006

Henry Darger
Young Fairy Winged Tuskorhorian. Poisonoious Blengiglominean Islands also Boyking Islands 542 B-G, date unknown
Watercolour and pencil on paper
35.6 × 43.2
Courtesy Kiyoko Lerner
© Kiyoko Lerner 2006

Gedewon
Sea of Southern Giter, 1991
Chemical ink on paper
100 × 75
Private collection
© Jacques Mercier

Gedewon
Diagram, 1991–92
Pen and chemical ink on paper
75 × 105
Courtesy Jacques Mercier
© Jacques Mercier

Gedewon
The Man, 1991–92
Pen and pigment on paper
105 × 75
Courtesy Jacques Mercier
© Jacques Mercier

cat. 17, p. 65
Gedewon
Untitled #13, 1992
Pen and chemical ink on paper
105 × 75
Courtesy Jacques Mercier
© Jacques Mercier

cat. 18, p. 66
Gedewon
Herbal Healing, 1993
Pen and chemical ink on paper
70 × 55
Courtesy Jacques Mercier
© Jacques Mercier

cat. 19, p. 67
Gedewon
Nedbén Zäpazyon, 1998–99
Pen and pigment on paper
110 × 75
Courtesy Jacques Mercier
© Jacques Mercier

cat. 20, pp. 70–71
Susan Hiller
Dream Mapping, 1974
3-night event, 7 dream notebooks
Notebooks by participants in individual
vitrines
Pencil, ink and watercolour on paper
Notebooks closed 18 × 23, open: 36 × 23,
Vitrines 41 × 46.5 × 22
Courtesy the artist

cat. 21, p. 73
Tehching Hsieh
One Year Performance (1978–79), 1979
Statement and poster
61 × 50.6
Courtesy Adrian Heathfield

cat. 22, p. 74
Tehching Hsieh
One Year Performance (1980–81), 1981
Statement and poster
61 × 50.6
Courtesy Adrian Heathfield

Tehching Hsieh
One Year Performance (1980–81), 1981
DVD on monitor
1 minute
Courtesy Adrian Heathfield

cat. 23, p. 75
Tehching Hsieh
One Year Performance (1981–82), 1982
Statement and poster
61 × 50.6
Courtesy Adrian Heathfield

Tehching Hsieh
One Year Performance (1983–84), 1984
Statement and poster
61 × 50.6
Courtesy Adrian Heathfield

Tehching Hsieh
One Year Performance (1985–86), 1986
Statement and poster
61 × 50.6
Courtesy Adrian Heathfield

Tehching Hsieh
13 Year Plan (1986–99), 1999
Statement and poster
61 × 50.6
Courtesy Adrian Heathfield

cat. 24, p. 77
Katarzyna Józefowicz
Untitled, 1994
Paper
Dimensions variable
Courtesy Collezione la Gaia,
Busca-Cuneo
© Foksal Gallery Foundation and
Katarzyna Józefowicz 2006

cat. 25, pp. 78–79
Katarzyna Józefowicz
Games, 2001–03
Mixed media
Dimensions variable
Courtesy Foksal Gallery Foundation
and Katarzyna Józefowicz
© Foksal Gallery Foundation and
Katarzyna Józefowicz 2006

Joachim Koester
The PAN Museum, 1999
Inkjet print
Dimensions variable
Courtesy the artist

cat. 26, insert between pp. 82 & 83
Joachim Koester
(text by Adrian Dannatt)
The PAN Museum, 2006
Newspaper
© Joachim Koester 2006
© Adrian Dannatt 2006

cat. 27, pp. 85–87
Paul Étienne Lincoln
Passage to Purification, 2001
(for display on wall)
24 resin coated photographic prints
Edition of 7, no. 3
21 × 21 each
Courtesy Alexander and Bonin, New York

Paul Étienne Lincoln
Passage to Purification, 2001
(for vitrine)
24 silver prints and pamphlet in cloth
covered box
Edition of 7, no. 3
21 × 21 each
Courtesy Alexander and Bonin, New York

Paul Étienne Lincoln
*Preparatory drawing for the borosilicate
still for the purification of Fagus
sylvatica var pendula II*, 2001
Pencil and coloured pencil on vellum
128 × 61
Courtesy Alexander and Bonin, New York

Paul Étienne Lincoln
*Preparatory drawing for the borosilicate
still for the purification of Fagus
sylvatica var pendula III*, 2001
Pencil and coloured pencil on vellum
132 × 61
Courtesy Alexander and Bonin, New York

Paul Étienne Lincoln
*Preparatory model for the pavilion
of Fagus sylvatica var pendula*, 2001
Bass wood, steel, wood and glass
39.4 × 91.4 × 20
Courtesy Alexander and Bonin, New York

Paul Étienne Lincoln
Purification DVD and Viewer, 2003
Exhibition copy
DVD displayed in viewer
8 minute loop
Courtesy Alexander and Bonin, New York

Paul Étienne Lincoln
Purification (Merope), 2003
Vitrine copy
DVD, leaf encased in etched glass
and copper in wood box with engraved
nickel plate
1.3 × 15 × 16.5
Courtesy Alexander and Bonin, New York

cat. 29, pp. 90–91
Mark Lombardi
*George W. Bush and Harken Energy and
Jackson Stephens, (5th version)*, 1988
Graphite on paper
61.5 × 122.6
Private collection
© Estate of Mark Lombardi and Pierogi,
2006

Mark Lombardi
*Inner Sanctum: The Pope and his
Bankers Michele Sindona and Roberto
Calvi, ca. 1959–82*, 1996
Graphite on paper
143.5 × 320.7
Private collection
© Estate of Mark Lombardi and Pierogi,
2006

Mark Lombardi
*Chicago Outfit and Satellite Regimes,
ca. 1931–83*, 1998
Graphite on paper
122.4 × 245.4
Courtesy Donald Lombardi and Pierogi
© Estate of Mark Lombardi and Pierogi,
2006

Mark Lombardi
Frank Nugan, Michael Hand, and Nugan Hand Limited of Sydney Australia,
ca. 1972–80, 1998
Graphite on paper
140.3 × 325.8
Courtesy Donald Lombardi and Pierogi
© Estate of Mark Lombardi and Pierogi, 2006

cat. 28, p. 89
Mark Lombardi
World Finance Corporation and Associates, ca. 1970–84: Miami, Ajman, and Bogota – Caracas (Brigada 2506: Cuban Anti-Castro Bay of Pigs veteran) (7th version), 1999
Graphite and coloured pencil on paper
75.2 × 150.4
Courtesy Joe Amrhein and Susan Swenson
© Estate of Mark Lombardi and Pierogi, 2006

Mike Nelson
Amnesiac Shrine, 2006
Mixed media
Dimensions variable
Courtesy the artist and Matts Gallery, London

cat. 30, p. 97
Kurt Schwitters
Merzbau (Barbarossa Grotto, probably identical with Kyffhäuser), 1925
Vintage photographic print
23.7 × 15.8
Sprengel Museum, and Kurt und Ernst Schwitters Stiftung, Hannover
(The foundation of the Kurt und Ernst Schwitters Stiftung is mainly due to the Schwitters family with the support of the NORD/LB Norddeutsche Landesbank, the Savings Bank Foundation of Lower Saxony, the Nieder-sächsische Lottostiftung, the Cultural Foundation of the Federal States, the State Minister at the Federal Chancellery for Media and Cultural Affairs, the Ministry for Science and Culture of the Land of Lower Saxony and the City of Hanover.)
Photo: Ernst Schwitters
© DACS 2006

cat. 32, p. 99
Kurt Schwitters
Merzbau (detail with Madonna), *c.*1930
Vintage photographic print
16 × 23.8
Sprengel Museum, and Kurt und Ernst Schwitters Stiftung, Hannover
(as above)
Photo: Ernst Schwitters
© DACS 2006

cat. 4, p. 28
Kurt Schwitters
Merzbau (detail: blue window), *c.*1933
Vintage photographic print
23.8 × 16.5
Sprengel Museum, and Kurt und Ernst Schwitters Stiftung, Hannover
(as above)
Photo: Wilhelm Redemann, Hannover
© DACS 2006

cat. 2, p. 25
Kurt Schwitters
Merzbau (detail: grand group), *c.*1932
Vintage photographic print
24 × 16.7
Sprengel Museum, and Kurt und Ernst Schwitters Stiftung, Hannover
(as above)
Photo: Wilhelm Redemann, Hannover
© DACS 2006

cat. 3, pp. 26–7
Kurt Schwitters
Merzbau (detail: stairway entrance), *c.*1932
Vintage photographic print
16.4 × 23.5
Sprengel Museum, and Kurt und Ernst Schwitters Stiftung, Hannover
(as above)
Photo: Wilhelm Redemann, Hannover
© DACS 2006

cat. 31, p. 98
Kurt Schwitters
Merzbau (Grotto in memory of Molde), 1935
Vintage photographic print
23.7 × 16.2
Sprengel Museum, and Kurt und Ernst Schwitters Stiftung, Hannover
(as above)
Photo: Ernst Schwitters
© DACS 2006

cat. 5, p. 40
Kurt Schwitters
Cottage on Hjertøya (after the extension with Ernst Schwitters), *c.*1935
Vintage photographic print
8.2 × 11.8
Sprengel Museum, Hannover
Photo: Kurt / Ernst Schwitters
© DACS 2006

Kurt Schwitters
Merzbau Sketch, 1946
Pencil on paper, modern reproduction print
12 × 20
Courtesy Stadtarchiv Im Fachberich Bibliotek und Schule
© DACS 2006

cat. 34, p. 101
Kurt Schwitters
Cottage on Hjertøya (interior view, towards south), 1953
Photograph, modern reproduction print
17.2 × 23.8
Sprengel Museum, Hannover
Photograph: Gisel Johansen
Courtesy Dietmar Elger
© DACS 2006

Kurt Schwitters
Cottage on Hjertøya (hall, general view), 2001
Colour photograph
15.2 × 10.2
Sprengel Museum, Hannover
(as above)
Photograph: Isabel Schultz, Hannover
© DACS 2006

cat. 33, p. 100
Kurt Schwitters
Cottage on Hjertøya (interior view, towards west, detail of 'Ofenecke'), 2001
Colour photograph
12.2 × 10.2
Sprengel Museum, Hannover
(as above)
Photograph: Isabel Schultz, Hannover
© DACS 2006

cat. 35, p. 103
The Speculative Archive
It's Not My Memory of It, 2003
DVD projection
25 minutes
Courtesy The Speculative Archive / Julia Meltzer and David Thorne
© Julia Meltzer and David Thorne, 2006

cat. 1, p. 23 & cat. 36, pp. 104–05
The Speculative Archive
In Possession of a Picture, 2005
24 colour photographs
23 × 34 each
Courtesy The Speculative Archive / Julia Meltzer and David Thorne
© Julia Meltzer and David Thorne, 2006

cat. 43, p. 118
Jeffrey Vallance
My FBI File, 1981
Silkscreen print on paper and 12-page file
38.1 × 54.6
Courtesy the artist and Lehmann Maupin Gallery, New York

cat. 38, p. 108
Jeffrey Vallance
Clowns and Shroud, The Four Clowns of Turin, 1998
Mixed media on paper
55.8 × 76.2
Courtesy the artist and Lehmann Maupin Gallery, New York

cat. 39, p. 109
Jeffrey Vallance
Prophetic Wound: The Stain of Washington, Blood Stain on the Shroud made by the Holy Lance, 1998
Mixed media on paper
55.9 × 76.2
Hort Family Collection
Courtesy the artist and Lehmann Maupin Gallery, New York

cat. 37, p. 107
Jeffrey Vallance
Shroud of Blinky Circular Logic, 1998
Mixed media on paper
55.9 × 76.2
Courtesy the artist and Lehmann Maupin Gallery, New York

Jeffrey Vallance
The Holy Lance of Longinus, aka Die Heilige Lanze, the Spear of Destiny, the Romphea, and the Spear of Saint Maurice, 1998
Mixed media on paper
55.9 × 76.2
Courtesy the artist and Lehmann Maupin Gallery, New York

Jeffrey Vallance
Catholic Leagues Report on Anti-Catholicism, 1999
Report cover, black and white larger copies, signed letters, envelope
73.7 × 101.6
Courtesy the artist and Lehmann Maupin Gallery, New York

Oskar Voll
Notebook (Inv. 328), 1910–20
Pencil on paper
21.5 × 27.8
Courtesy Prinzhorn Collection, Heidelberg
© Sammlung Prinzhorn Heidelberg

Oskar Voll
Notebook (Inv. 318), 1910–20
Pencil on paper
20.0 × 26.1
Courtesy Prinzhorn Collection, Heidelberg
© Sammlung Prinzhorn Heidelberg

cat. 40, p. 111
Oskar Voll
Notebook No. 7 (Inv. 344), 1910–20
Pencil on paper
27.9 × 21.5
Courtesy Prinzhorn Collection, Heidelberg
© Sammlung Prinzhorn Heidelberg

Oskar Voll
Notebook No. 8 (Inv. 350), 1910–20
Pencil on paper
27.9 × 21.5
Courtesy Prinzhorn Collection, Heidelberg
© Sammlung Prinzhorn Heidelberg

cat. 6. (p. 42), cat. 41. (p. 112), cat. 42. (p. 113),
Oskar Voll
Notebook No. 9 (Inv. 360), 1910–20
Pencil on paper
32.9 × 20.6
Courtesy Prinzhorn Collection, Heidelberg
© Sammlung Prinzhorn Heidelberg

LIST OF FIGURES

Fig. numbers refer to illustrations not included in the exhibition.

fig. 1, pp. 2–3
West wall of Henry Darger's room, 1978
Photograph
Image courtesy Kiyoko Lerner
Image © Michael Boruck

fig. 2, p. 10
Ernst Schwitters (in cap) and unknown child in front of 5 Waldhausenstrasse, April 1926
Photograph courtesy Kurt and Ernst Schwitters Foundation
© DACS 2006

fig. 3, p. 12
Kurt Schwitters
Merbarn Wall Relief, 1947–48
Mixed media
Image courtesy Hatton Gallery, University of Newcastle Upon Tyne, UK / The Bridgeman Art Library
© DACS 2006

fig. 4, p. 17
Susan Hiller
Dream Mapping: Dreamers in a field, Purdies Farm, Hampshire, 1974
Photograph (documentation of performance)
Dimensions variable
Courtesy the artist

fig. 5, p. 33
Kurt Schwitters, *Untitled (Merz column)*, c.1923
Sculpture and assemblage, paper, cardboard, metal, plaster, wood, croucheted cloth, cow horn, laurel branch, scones and diverse material on wood
Photograph courtesy Kurt Schwitters Archives at Sprengel Museum, Hannover
© VG Bild-Kunst, Bonn

fig. 6, p. 34
Kurt Schwitters, *Untitled (column with boy's head, part of the Merzbau)*, 1925
Sculpture and assemblage
Photograph courtesy Kurt Schwitters Archives at Sprengel Museum Hannover
© VG Bild-Kunst, Bonn

fig. 7, p. 36
Robert Wiene, *The Cabinet of Doctor Caligari*, 1920, (film still)
Image courtesy British Film Institute
© Friedrich-Wilhelm-Murnau-Foundation, Wiesbaden.
World Sales: Transit Film GmbH, Munich

fig. 8, p. 37 & fig. 9, p. 39
Marcel Duchamp, *Étant donnés: 1 la chute d'eau, 2 le gaz d'eclairage (Given: 1 The Waterfall, 2 The Illuminating Gas)*, 1946–66
242.6 × 177.8
Mixed-media assemblage: wooden door, bricks, velvet, wood, leather stretched over an armature of metal, twigs, aluminium, iron, glass, Plexiglas, linoleum, cotton, electric lights, gas lamp (Bec Auer type), motor, etc.
Accession no.: 1969-41-1
Philadelphia Museum of Art: Gift of the Cassandra Foundation, 1969
© Succession Marcel Duchamp/ADAGP, Paris and London, 2006

fig. 10, p. 46
Jean Mar, *Promenade du Roi et de la Reine*, c.1908
Graphite on paper
25 × 15
Collection de l'art Brut, Lausanne

fig. 11, p. 47
Oskar Voll, *Untitled drawing* (Inv. 282), date unknown
Pencil on paper
24.8 × 31.5
Inv. 282
Prinzhorn – Collection, Heidelberg
© Sammlung Prinzhorn Heidelberg

fig. 12, p. 55
Roberto Cuoghi, *Untitled (anaglyph version)*, 2005
dimensions variable
Courtesy Galleria Massimo De Carlo

fig. 13, p. 69
Susan Hiller, *Dream Mapping (Composite Group Dream Map, August 23, 1974)*, 1974
Ink and watercolour on paper
18 × 23
Courtesy the artist

fig. 14, p. 81–83
Joachim Koester, *The Pan Museum*, 1999
Colour photographs
Dimensions variable
Courtesy the artist

fig. 15, p. 94
Mike Nelson, *Master of Reality*, Berwick Gymnasium Gallery, Berwick-upon-Tweed
Ink on paper sketches
Notebooks closed 135 × 85
Courtesy the artist and Matts Gallery, London

fig. 16, p. 95
Mike Nelson, *AMNESIAC SHRINE or Double coop displacement*, Matts Gallery, London
Ink on paper sketches
Notebooks closed 135 × 85
Courtesy of the artist and Matts Gallery, London

117

checked on 9/21/76 by SC ███████████ revealed subject
was arrested on 6/22/75. He was found lying in the
muck in a ditch and was noted to be babbling and
sporatically attempting to abuse himself. ██████████
██████████ were of the opinion this individual was under
the influence of some unknown substance and unable to
care for himself. VALLANCE later stated he had "some
grass". According to these records, VALLANCE was
attending Pierce College in Woodland Hills, California,
where he was pursuing general academic studies. (U)

9/28 my FBI File Jeffry Vallance 1981